FREDERIC REMINGTON

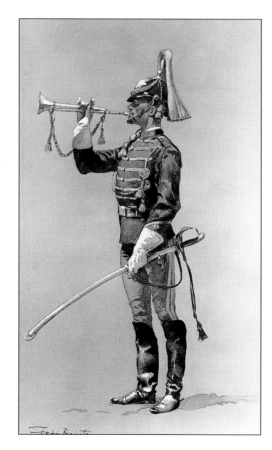

Taps. (Cavalry Bugler in Full Uniform) 1890

Watercolour on paper. 17¹/₂ x 10¹/₂ inches (44.5 x 26.7cm).

The Frederic Remington Art Museum, Ogdensburg, New York.

Published in 1997 by
Grange Books
An imprint of Grange Books Plc
The Grange, Grange Yard
London SE1 3AG

Printed in China

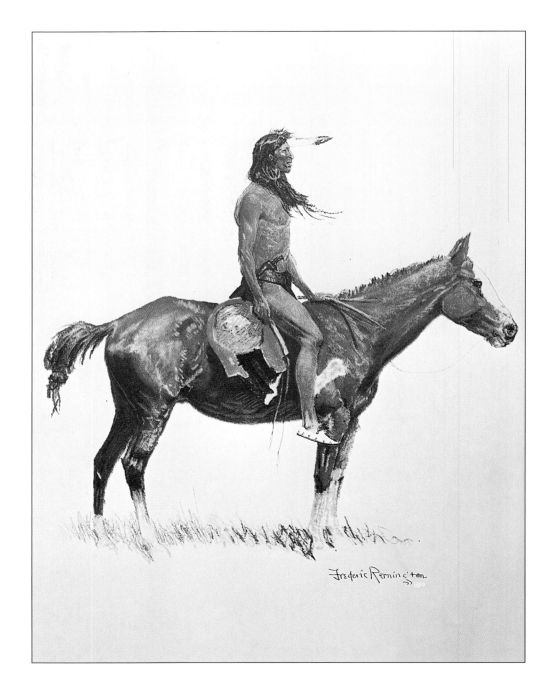

A Cheyenne Brave 1901
From a portfolio of 8 colour photolithographs first
published as 'A Bunch of Buckskins'
Pastels. 15 x 20 inches (38.1 x 50.8 cm).
Peter Newark's Western Americana.

FREDERIC REMINGTON

Rupert Matthews

Grange BOOKS

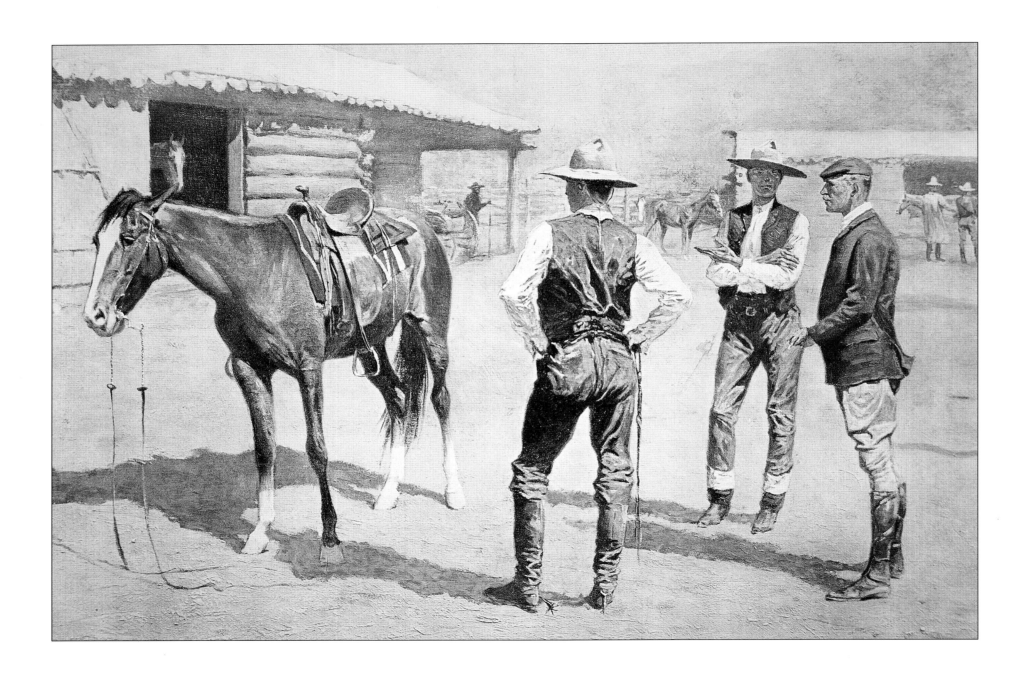

Contents

Buying Polo Ponies in the West.
From a painting published in The Illustrated Sporting and Dramatic News *of*
14 May 1910.
Peter Newark's Western Americana.

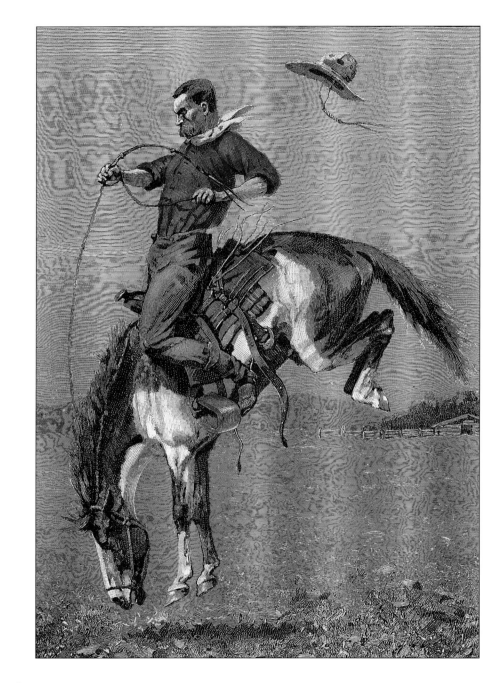

Bronco Buster (c. 1900)
Colour engraving.
Peter Newark's Western Americana.

Chapter One
New York

Whenever the name Frederic Remington is mentioned, the early days of the American West spring immediately to mind. From the days of his youth it was apparent that he possessed a natural talent as a draughtsman and, once he discovered a love of the outdoor life, he set about recording some of the most colourful, if bloody, episodes of the history of his country. As his fascination with the West grew, and with it the mastery he displayed at capturing its spirit, a group of European painters who would come to be known as the Impressionists were finding unprecedented ways of reproducing the fugitive effects of light and shade and some of this was to rub off on Remington as his career progressed.

Yet for all his love of the West and skill in depicting it, Remington came from as solid an Eastern family as it was possible to find. By the time he travelled West, many of the great epic events were already history. Custer and Wild Bill Hickok were both dead, the mighty Texas longhorn drives were over and the James-Younger Gang had been broken up. It was Remington's determination to capture the last days of the old frontier in pictorial form that drove him on. His collection of memorabilia was unrivalled, as was his knowledge of the old days, gleaned from long hours of conversation with veterans of those troubled times. An interest in exploring the outer limits of civilization was born in Remington as a youth, when many of his Eastern compatriots regarded the West as a wild and dangerous place, best avoided at all costs.

The family into which Frederic Sackrider Remington was born on 4 October 1861 lacked neither money nor connections. Neither was it lacking a respectable ancestry. His grandmother could trace her family back to Stephen Hopkins who crossed the Atlantic on the *Mayflower* in 1620. The Remingtons themselves had been in America almost as long, having arrived in Massachusetts from England in 1637.

When Frederic was born, mass emigration from Europe was well under way. Belonging to a well-to-do, long-established American family was therefore of high value in a society which included so many penniless newcomers. Young Remington had American predecessors in plenty, well able to ease his path as he grew to manhood.

As a young child, however, Remington saw little of his father and male relatives. The Civil War had broken out in April 1861 and the Remingtons were heavily involved. His father, Seth Pierpont Remington, was the owner of the *St. Lawrence Plaindealer*, a newspaper with strong Republican sympathies. His fervent support of Lincoln left him no choice but to back the Unionist cause against the Confederate rebel states. While his son lay in the cradle, Seth Remington spent time and money raising recruits for the local cavalry regiment, the 11th New York and the small up-state town of Canton resounded to the unfamiliar tramp of marching feet. In March 1862 Seth himself joined the regiment as a captain, sold his newspaper, and left his family to their own devices.

Seth spent his war in respectable, but relatively undramatic ways in campaigns in Virginia and along the Mississippi River. A few months before the

end of hostilities, he was promoted to the temporary rank of brevet Lieutenant Colonel. Although the temporary rank was never confirmed, Seth proudly continued to use the title of Colonel after he left the army in March 1865. Returning to Canton, Colonel Remington bought back the *St. Lawrence Plaindealer* and once again threw himself head first into politics. So successful was he at promoting the Republican cause that he came to the notice of President Grant, his former army commander, in 1870. Grant gave Remington the safe and lucrative post of Collector of the Port of Ogdensburg, on the St. Lawrence river. The newspaper was sold yet again, though the Colonel later became editor of the *Ogdensburg Journal*.

Throughout these years the young Remington was exposed to what were to become a central feature of his later art; horses. The Colonel was a keen follower of harness racing and part owned a few mounts. He often took his son along to meetings and Remington attributed his abiding love of horses to the influence of his father. By 1874, however, it was clear that Frederic needed more challenging studies than the schools of Ogdensburg could offer. He was sent to the Vermont Episcopal Institute, Burlington, for two years before transferring to the Highland Military Academy in Massachusetts.

At this time, the army was seen as a suitable future career for Remington. There could be no doubt that the young man was keen on the life; any offspring of an old New England family could do a great deal worse than pursue a career as a soldier. Although the corrupt régime of President Grant, one-time victorious commander in the Civil War, had somewhat tarnished the reputation of the military at that time, the army was still riding the crest of a wave. Many men, now leaders in industry and government had themselves served in the the War, which obviously gave them solidarity with their old profession. Moreover, the army was actively involved against hostile tribes on the western plains: the duties of protecting settlers and miners was a tough and honourable one, guaranteed to earn soldiers the respect of the public at large.

Just a few weeks before Remington joined Highland Academy, General Custer had been wiped out by the Sioux and Cheyenne under Crazy Horse on the banks of the Little Bighorn river. General Crook was sent out with a new army to confront the tribes and as Remington arrived at Highland, news came through of a great battle at Slim Buttes where Crook had won a decisive advantage.

Remington himself had personal reasons for favouring the army. His father's career in the Civil War may have been relatively minor but it was nonetheless heroic, even though there can be little doubt that the tales of his exploits grew in the telling. So much so, in fact, that Remington's mother later tried to have the brevet rank of colonel posthumously made up to a permanent rank. No doubt the Remington family felt that Seth deserved nothing less for his heroism but the War Office, on the other hand, had no intention of paying out the extra pension appropriate to a colonel's widow. The request was refused and Remington senior remained officially a major.

His innate love of horses gave Frederic a further reason to consider an army

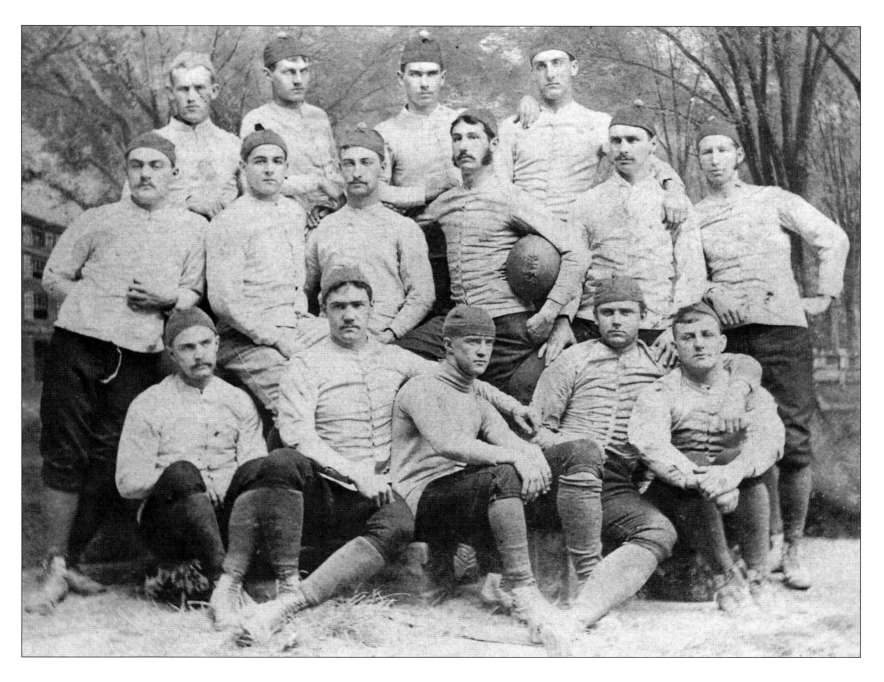

In the Fort Grant Corral 1886 (*c. 1905*)
Sketch.
Frederic Remington Art Museum, Ogdensburg, New York.

career. His father had served in the cavalry and had evidently enjoyed the experience and the chance to follow in his father's footsteps therefore held obvious attractions. Joining the cavalry would allow him to work with horses, engage in a respected profession and at the same time earn a living.

It is ironic, therefore, that the artistic streak which was to effect a change of direction in Remington's plans for a future career should first reveal itself at Highland while preparing for the military life. Between lessons in tactics and academic subjects, Remington made cartoons and caricatures of staff and pupils at the Academy. His admiration for cavalry led him to produce a number of pictures of the armies he was studying, Cossacks, Spanish riders and U.S. Cavalry being frequent subjects for his drawings.

When a friend introduced Remington to an artist named Scott Turner, the 16-year-old began to take his artwork far more seriously. He sought to improve his pen-and-ink technique and scenes and characters around the Academy became favourite subjects as he began to draw from life.

By 1878, any thoughts the young Remington may have had of a military life had been abandoned. In the fall of that year he transferred to Yale to attend the School of Fine Arts. Entering the school for the first time, he was confronted with an inscription on the wall which read 'Drawing is the Probity of Art'. It was a concept which was to guide Remington throughout most of his subsequent career: they were the words of John Niemeyer, Yale's principle drawing master.

Niemeyer was highly respected as an illustrator; more important was his ability to pass on his mastery of technique and perspective to his pupils. He believed the importance of line could not be over-estimated and would re-emphasize the fact at every lecture. Under his direction, Remington produced drawing after drawing and still life studies based on classical sculptures: a gradual, though definite, improvement could be seen as the skills of the young artist began to develop.

It was also at Yale that Remington met several people who were to prove influential in later life. One was a fellow student, Robert Camp, who later introduced him to ranching. A second student, Poultney Bigelow, went into publishing and gave Remington a break when he needed it most. Remington also made the acquaintance of John Weir, a professor of art, who would bring indirect influence to bear on Remington's career in the future.

That autumn, the young Remington returned home to Ogdensburg on a visit. There he met Eva Caten from nearby Gloversville and the two were immediately attracted to one another. By this time Remington was filling out to become a fine-looking young man. He played for Yale as rusher in the football team and was counted an asset to the squad. A couple of years later a young woman reported that he looked 'like some Greek god in modern clothing. He was tall, blond and wore a small mustache'. Eva was herself considered something of a beauty in up-state New York and neighbours commented on what a handsome couple they made. However, the courtship was interrupted by Remington's return to Yale for the autumn term.

The road to becoming a professional artist was not destined to be a smooth one for Remington. On 18 February 1880, his father died after a short illness. Not yet 18, Remington was still legally a minor and not yet able to conduct his own affairs. He was therefore made the ward of his uncle, Lamartin, who worried that his new charge was in danger of wasting his life as a second-rate artist instead of settling down to a sensible job. The fact that the Colonel had left Frederic nearly $10,000 merely served to increase his uncle's sense of unease. With such a legacy at his disposal the boy would, if he chose, be able to support himself as an artist until it became too late to train for a proper profession. Lamartin put his foot firmly down.

Through extensive family connections in the Republican Party and New York government, Lamartin was able to get his nephew a job in the office of the State Governor, A.B. Cornell. Remington was less than happy with this: the nature of the work failed to interest him and he was often to be found in another world, his work pushed aside, absorbed in sketching one office incident or another. In his leisure time, the young man took up riding as a pastime and every opportunity was taken to visit the Caten household to continue his courtship of young Eva.

Having failed to impress his superiors at the Governor's office with his business acumen, Remington was transferred to the Department of Public Instruction, where Lamartin himself worked. If his uncle thought that by keeping an eye on him he could better control his wayward nephew, he was sadly mistaken. The young man showed no more inclination to work at a desk job than he had before. Moreover, he took to visiting a friend's room in the evenings to play cards and, of course, draw.

In the spring of 1881, circumstances conspired to change the course of Remington's life. Eva's parents turned down his request for their daughter's hand and made no secret of the fact that they considered him an unworthy suitor, lacking in prospects for the future. His uncle followed by losing his patience and abandoned his attempts at persuading his nephew to stick to a steady career. He began to think that a long trip might cure the boy of his wanderlust once and for all. In August, therefore, the young man departed on his journey to the western plains. His family may have hoped that, once returned, he would settle down to a steady job and be a welcome visitor to the Caten household once again.

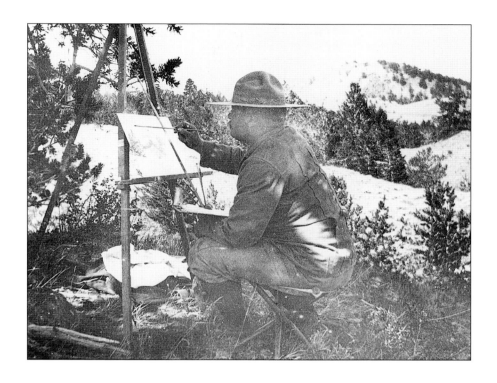

Whatever the reasoning, Remington climbed aboard the *Northern Pacific Railroad* and headed out west. His route took him across North Dakota and into Montana. Here he left the railroad and began to explore the northern plains for some weeks.

The western plains which Remington visited in the summer of 1881 were rapidly changing. The extermination of Custer's famed 7th Cavalry in 1876 had proved to be an illusory victory for the Plains tribes. A minor victory by Crazy Horse on the Powder River had enabled him and Sitting Bull to gather the largest-ever camp of tribes on the Rosebud as Sioux, Cheyenne and Arapaho poured in to join the victorious Crazy Horse. After Custer's death the U.S. Army launched a determined winter campaign which shattered the alliance of the tribes. Crazy Horse himself surrendered with his Sioux in February 1877, Chief Joseph surrendered in October and Sitting Bull fled to Canada. Every tribe of the plains had been confined to a reservation.

Once the tribes had been removed from the western plains, the white man could move in. The Black Hills of Dakota were the first to be occupied as thousands of miners rushed to take advantage of a gold strike. The plains were the next area to be settled. Cowboys and ranchers from Texas moved steadily north with their cattle to establish vast range empires where buffalo had once grazed. In 1881, the year Remington headed west, the last great cattle drive from Texas arrived in Dodge City, Kansas. Ranchers in Wyoming, Dakota and other territories were producing their own beef, while railroads were pushing into Texas itself.

That same year, two great events of Western history took place. On 4 July the outlaw Billy the Kid was shot down in Fort Sumner in New Mexico. William H. Bonney – the Kid's real name – had killed 21 men by the age of 18, taken part in a range war and stolen more horses than most people could remember. Some time later, in October, an even more famous shoot-out took place in Arizona. Marshall Wyatt Earp, backed by two of his brothers and friend Doc Holliday, faced the Clanton rustling gang at the O.K. Corral in Tombstone. Four of the Clanton gang were killed in the subsequent gunfight, which lasted only seconds.

While such mayhem proved that the West was as wild as ever, other events gave some indication of new beginnings for the future. A vast area of the Yellowstone Valley in Colorado and Wyoming was designated the Yellowstone National Park. The park was established to protect the scenic grandeur of the area from the attentions of miners, lumberjacks and industrialists who were making

their way west. That such protection was considered necessary suggested that the U.S. Government could see the prospect of a more peaceful West on the horizon.

Certainly the Canadian Government had no doubts that this was true. In a move foreshadowing Remington's later commissions, the Marquis of Lorne, Governor-General of Canada, employed an artist to produce a pictorial record of the West. The artist Lorne chose was Sydney Prior Hall, an established illustrator with the *London Graphic* who had covered the Marquis's marriage for the society pages in 1871. In 1881 Hall travelled west, with instructions to send back illustrations guaranteed to attract settlers to the plains, the Canadians having managed to avoid the fighting with the Plains tribes which had engulfed the United States further south. The Canadian tribesmen were rapidly taking to farming and were being hired by various mining and ranching companies.

Accompanied by the reporter, Dr. MacGregor, Hall made a good beginning. In August, while Remington was wandering around Montana, Hall was drawing lush meadows and fertile farmland together with railroads, churches and other trappings of civilization and his drawings were sent back East for publication in Canadian and British magazines. In September, Hall, accompanied by Lord Lorne, attended the great pow-wow of the Blackfoot tribe on the Bow River. Hall was fascinated with the Blackfoot and Cree and began to focus his attention on the costumes and religious ceremonies of the tribes. The Canadians were not impressed. 'Mr Hall has confined himself too much to sketching Indian pow-wows,' declared a newspaper in Winnipeg.

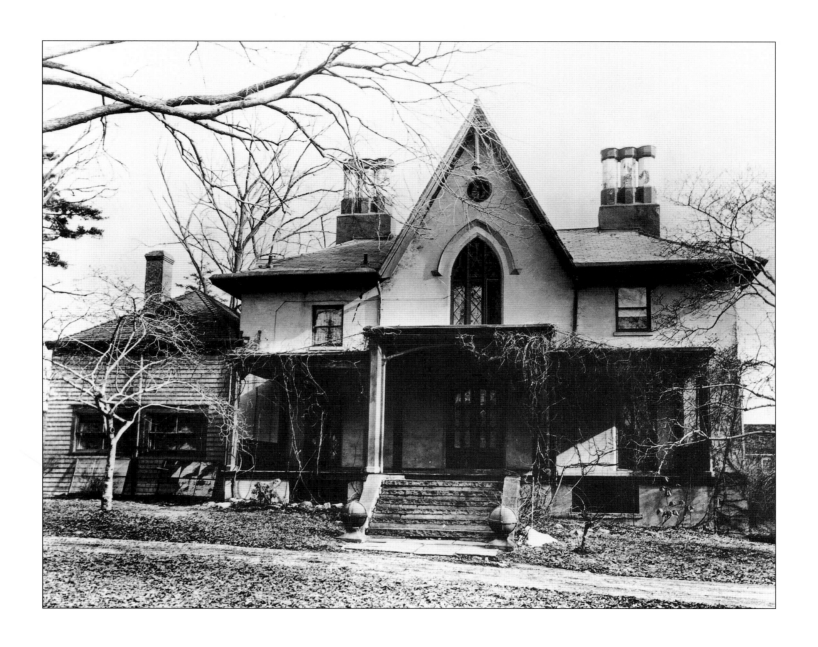

Nevertheless, Hall achieved his purpose. The year after his sketches were published, 70,000 settlers headed for the Canadian plains. It is not certain if Remington was aware of Hall's work at the time, certainly his drawings reflect none of Hall's stylistic quirks. However, the immense popularity of Hall's published drawings and engravings had a most definite impact on his career once his trip was over.

Remington had been almost as busy with his sketching as Hall. He spent several weeks in the company of the miners, ranchers and muleskinners who dominated the northern plains in 1881. Though he did not precisely record the details of his travels, Remington later claimed to have covered hundreds of miles. What is certain is that Remington became extremely attached to the region and to its colourful inhabitants.

One of these characters made a particularly strong impression on the artist. After he had become famous, Remington frequently retold the story of this encounter as a way of explaining his lifelong fascination with the frontier. According to an account of a conversation Remington had with a reporter in 1909, he had been out riding the Montana range when he found himself far from a settlement as night fell. Fortunately he spotted the camp of a wagon freighter and requested a night's shelter.

From their chat, seated round the camp fire, it emerged that the freighter (Remington did not give his name) had been born and raised in up-state New York, as had Remington. *'I was nineteen years of age and he was a very old man,'*

said Remington. *'He had gone west at an early age. His West was Iowa. Thence, during his long life he had followed the receding frontiers, always further and further West. "And now," said he, "there is no more West. In a few years the railroad will come along the Yellowstone." '*

The meeting had a profound effect on Remington. He realized that the sights and sounds he had encountered and his adventures in Montana and Dakota over the past few weeks were soon to be things of the past under the relentless advance of progress and encroaching civilization. *'Without knowing exactly how to do it,'* said Remington, *'I began to try to record some facts around me, and the more I looked the more the panorama unfolded.'*

Remington's works were to reflect this period, again and again. In 1890 he produced a pen-and-ink study of *The Old Transcontinental Freighter.* In this picture Remington manages to authentically capture the spirit of the freighters who conveyed goods across the vast plains. The six mules are straining forward under the weight of the heavy covered wagon which they are dragging through thick dust. The freighter himself sits slouched on the wheel mule, his wide-brimmed hat pulled down to shade his eyes from the sun's glare. Even though it was produced nine years after this fateful meeting, the work could have been done from life.

Although Remington gave slightly different accounts of this meeting in later life there is no reason to doubt its essential truth. The image of a young 'tenderfoot' squatting at a camp fire on the lone prairie, lost in the tales of a

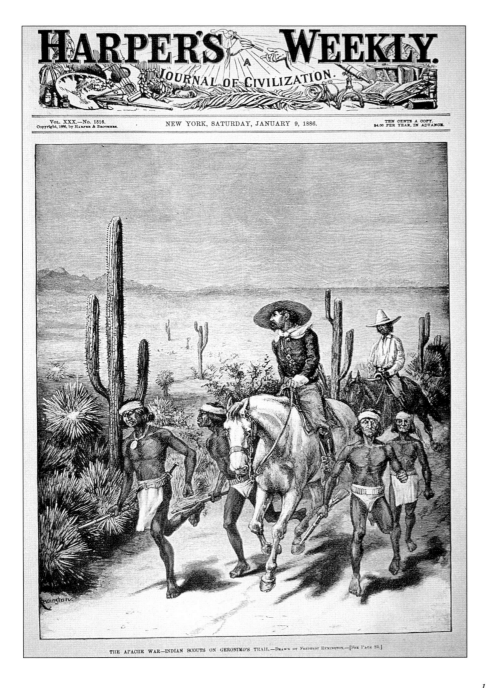

HARPER'S WEEKLY.

A JOURNAL OF CIVILIZATION.

VOL. XXX.—No. 1516.
Copyright, 1886, by HARPER & BROTHERS.

NEW YORK, SATURDAY, JANUARY 9, 1886.

TEN CENTS A COPY.
$4.00 PER YEAR, IN ADVANCE.

THE APACHE WAR—INDIAN SCOUTS ON GERONIMO'S TRAIL.—DRAWN BY FREDERIC REMINGTON.—[SEE PAGE 23.]

weather-beaten frontiersman, is full of romance. The encounter certainly rings true, both as an indication of Remington's state of mind and his attitude to the inhabitants of the plains at that time. It would explain much about Remington's subsequent behaviour: he could never quite abandon the benefits of his privileged upbringing back East, but neither could he forget the love and respect for the ways of the vanishing frontier that were born that night.

After two months travelling the plains, Remington returned home. He was convinced that he had managed to capture the essence of an fast-disappearing era and that his sketches deserved to be seen, not only by his own family, but by the wider world at large. His old ambition to become a full-time artist remained undimmed. By a combination of good luck and useful contacts, Remington managed to get an appointment to see George Curtis of *Harper's Weekly*, the New York magazine. *Harper's* was well known for publishing artworks and Remington hoped to interest Curtis in his own.

As Curtis flicked through numerous sketches submitted by the young hopeful there seemed, at first sight, little there to interest him. It is notoriously difficult to gauge the reaction of critics to the early works of artists who later turn out to be successful. There is always a temptation to claim, with hindsight, that one recognized the first glimmerings of genius before anyone else. However, in this instance, it is clear that Remington's work was simply not good enough to be published.

Nonetheless, Curtis was well aware of the public's increasing appetite for pictures and illustrations of frontier life. The work of Hall was beginning to appear in print to much acclaim. More importantly, Curtis knew that *Harper's* had been severely criticized in the past for publishing work not quite authentic in every detail. Anxious to obtain material, *Harper's* had been in the habit of commissioning artists who had never actually visited the scene to produce illustrations of news and events reported second-hand from the frontier. When the veterans returned they were scathing about the glaring inaccuracies, illustrations of the Modoc War of 1873 being particularly humiliating for *Harper's*.

Now Curtis saw before him a young artist, newly returned from the West, complete with bulging portfolio of pictures conceived and executed on the spot. Curtis bought one of Remington's drawings, even though it was not quite up to

Medicine Elk (c. 1888)
Wood engraving.
Frederic Remington Art Museum, Ogdensburg, New York.

the standards of the magazine, and gave it to a staff artist, William Rogers, to redraw. Fortunately for Remington, Rogers was quite well acquainted with the minutiae of Western dress and trappings as he had been hired in the first place to check on such things. Although the sketch remained identifiable as Remington's, he signed it with his own name. Remington was, however, mentioned as having produced the original sketch from life.

Remington was thrilled. He had been published, and at the age of just 20. This success, however, did not generate sufficient financial reward to be termed a new career and Remington returned to his hated office life. Although he was allowed to visit Eva Caten, her father still withheld permission for them to marry.

It was not all doom and gloom, however. In October 1882 Remington was due to receive his father's legacy and began to plan what he would do with it. No doubt Uncle Lamartin, being older and wiser, gave him sensible advice on how he should invest the money in order to provide a safe and steady income for the future. But Remington had other ideas. He was planning to return both to the West and to his life as a serious painter.

Chapter Two
Out West

As the long summer of 1882 dragged on, Remington looked forward to his 21st birthday in October when he would gain full control of his late father's bequest. No longer would he be restricted by the well-intentioned, if irritating, advice of his guardian.

The previous April, news had arrived that the famed outlaw Jesse James had been shot dead in Missouri. Although such news rather confirmed Remington's suspicions that the violent days of the old West might be drawing to a close, events in Arizona indicated otherwise. A gang of outlaws, calling themselves The Cowboys, had been harassing the miners to such an extent that the U.S. Army was called in to deal with them. Such news from the frontier could only serve to increase Remington's burning desire to head back to the West.

Remington's old Yale colleague, Robert Camp, had himself earlier migrated to the West to take up ranching. Camp ran a sheep ranch in Kansas and soon found himself the recipient of letters full of searching questions from his friend. Camp replied that, with the amount of money Remington had at his disposal, a cattle ranch was out of the question but that sheep were a more sensible proposition. Moreover, Camp added, he would be happy to advise Remington on the various aspects of their management.

No doubt the idea of investing his inheritance in a Kansas sheep ranch was discussed with his uncle, though it is unclear what the elder Remington's reactions were to the idea. But he may have felt cautious optimism that his nephew was at last beginning to find his niche in life. He agreed to visit Frederic as soon as the boy had settled down and was well established in his new venture.

Uncle Lamartin had good reason to be hopeful. In 1881 the respected General James S. Brisbin had published a book entitled *The Beef Bonanza*, which reported various figures, facts and legends of the western range. Brisbin drew on the accounts of the first wave of settlers and ranchers who migrated to the West in the 1860s and 1870s as the tribes were driven off. He estimated, not without reason, that the return on investment for a rancher would be about 40 percent after 7 years. It seemed too good a chance to miss. Sadly, as Remington was about to find out, the West was not the place it had been in the 1860s and profits were now far less easy to come by.

In February 1883 Remington headed west to join Robert Camp in Kansas. As he set out, he crossed paths with one of the great legends of the West. Buffalo Bill was heading east with his Wild West Show. The show opened in Nebraska in May and featured a small herd of buffalo, several cowboys, native tribesmen and Mexican *vaqueros*. In his first show, Buffalo Bill had his team play act at hunting buffalo, holding up stage-coaches and fighting pitched battles. William Cody was 16 years older than Remington and had spent almost his entire life on the frontier where he was once a scout in the wars with the Plains tribes. He had variously earned a living, sometimes as a pony express rider, sometimes by shooting buffalo to supply meat to the railroad workers, hence his nickname. His show proved to be a great success and he later took it on tour to Europe.

Remington, meanwhile, had humbler ambitions. He spent a few weeks with

The Noonday Halt (c. 1887) *Pen and ink on paper. 8¹/₄ x 13³/₈ inches (21 x 34cm). Frederic Remington Art Museum, Ogdensburg, New York.*

Camp, getting to grips with the practicalities of sheep ranching and meeting the workers and traders with whom he would sooner or later have to be involved. Eventually he bought himself a double quarter-section near the town of Peabody and, purchasing a flock of sheep and hiring hands to help him, Remington embarked on his new career as a sheepman.

It is possible that no denizen of the old West has been quite so misunderstood as the sheepman. In countless novels and movies, the sheepman is portrayed as a shiftless, detested figure. He often figures either as a villain, intent on driving honest cowboys from the range, or as a buffoon fit for nothing but ridicule. Such a reputation is undeserved, given the large numbers of sheep and sheepmen on the open range, but it is rooted in fact.

One cowboy, writing in 1896, said: *'A great enemy to the cattle trade has for years been growing up. This menace is no less than the sheep industry, itself a great one, albeit cordially detested by your genuine cowman, who has a deep-seated contempt for anyone who will look at a sheep. One of these great flocks of sheep coming over the native range of a local band of cattle will eat off the grass so closely that the cattle will leave the range or starve to death upon it. This year sheep are coming over some of the Wyoming free-grass country in such numbers that many cattle men have shipped their cattle out of the country. Yet others have sold out entirely.'*

Such allegations, though exaggerated, possessed a grain of truth. Sheep do certainly crop grass very close, too short for cattle to graze. However, this close cropping can be beneficial in the long run. Sheep eat not only grass but also the various prairie weeds which colonize the long grass on which cattle graze. In a few weeks, a pasture grazed by sheep will recover to be better than it was before. Other cowboys claimed that sheep stirred up the alkali dust in water-holes with their sharp hooves, making the water unfit for cattle, or that they so polluted the land with their droppings that cattle would avoid it until rain had cleansed the soil.

It is possible that the great cattle driver, Jack Culley, came closest to the truth in his autobiography. *'Certainly the prejudice against sheep in the early days was very strong,'* he wrote of the 1870s. *'I think it came to us from the Texans, from whom we derived our range practice. The Texan associated sheep with Mexicans, and from the day of the Alamo for many years, nothing Mexican looked good to the Texans. Furthermore, practically the whole range country owed its development to the cowman. The cowman felt he had a right to call the country "cattle country" and to regard the sheepmen as intruders. Sheep spelled chaos – and war.'*

Some years later, Remington produced a drawing of just such a figure as Culley described. Called *The Sheep Herder's Breakfast*, the picture shows a lone figure seated beside a fire on which a coffee pot is standing. Beside him lies a Mexican hat and saddle while a donkey and a dog wait patiently nearby. The sheep are shown as white blurs in the distance. He returned to the theme with his *Navajo Sheepherder*, though here the sheepman is a tribesman from the south-west, rather than a Mexican interloper into cattle country.

ABOVE
The Capture of the German (c. 1888)
Oil on board. 14 x 17$^{1}/_{2}$ inches (35.6 x 44.4 cm).
Frederic Remington Art Museum, Ogdensburg, New York.

OPPOSITE
My Ranch (1883)
Watercolour and pen and ink on paper. 9 x 11 inches (22.9 x 27.9 cm).
Frederic Remington Art Museum, Ogdensburg, New York.

Despite such prejudices, Remington was undeterred. He had been on the northern range before sheep had arrived in great numbers and may not have been aware of the animosity they caused among cowboys. It is possible that his youth and the unshakeable self-confidence engendered by his upbringing back East made him feel that he could easily overcome such obstacles.

Unfortunately, one of Remington's first actions served to mark him out as an Easterner who knew little about the West. He bought a palomino horse and, even worse, gave it a name. Remington himself was delighted with Terra Cotta. He wrote home how the horse had 'a stride like steel springs under me as she swept along, brushing the dew from the grass of the range'. The palomino was a half-breed, born out of a Texas carriage horse crossed with a thoroughbred stallion. Such horses were rare on the range. Although undoubtedly beautiful they were viewed with contempt by the old hands, especially on the southern range.

As an Easterner it was not unnatural that Remington would favour such fine horseflesh. But his later paintings indicate that he may soon have learned his lesson, for his portrayal of the typical cow pony is full of affection and attention to detail. These hardy animals, having originated in North Africa, were descended from the first horses brought to America by the Spanish.

After years on the plains the horses became adapted to the conditions there. They never exceeded 14 hands nor weighed over 600 pounds. The cow pony had a short neck, flat ribs and rather narrow hips. The shoulders were typically set at an angle and the chest was deep, almost barrel-like. Together these features gave the cow pony enormous stamina and agility. What it lost in speed and beauty it more than made up for in skills that really mattered when working the range.

By the time Remington reached Kansas the cow pony had become almost an established breed. The first horses to be used for cow work had been wild mustangs, trained to take instructions from the reins and spurs. The hunting and training of these horses had once been a great trade in which, for some reason, freed slaves were experts. But by about 1878 all the large herds of mustangs had been taken. Only in the Texas Panhandle did a few small herds survive until about 1897. In their place had grown up the horse ranch, where ponies were raised and trained specifically for hard work on the range. It was these horses that Remington studied during his time in the West and which he later included in his work.

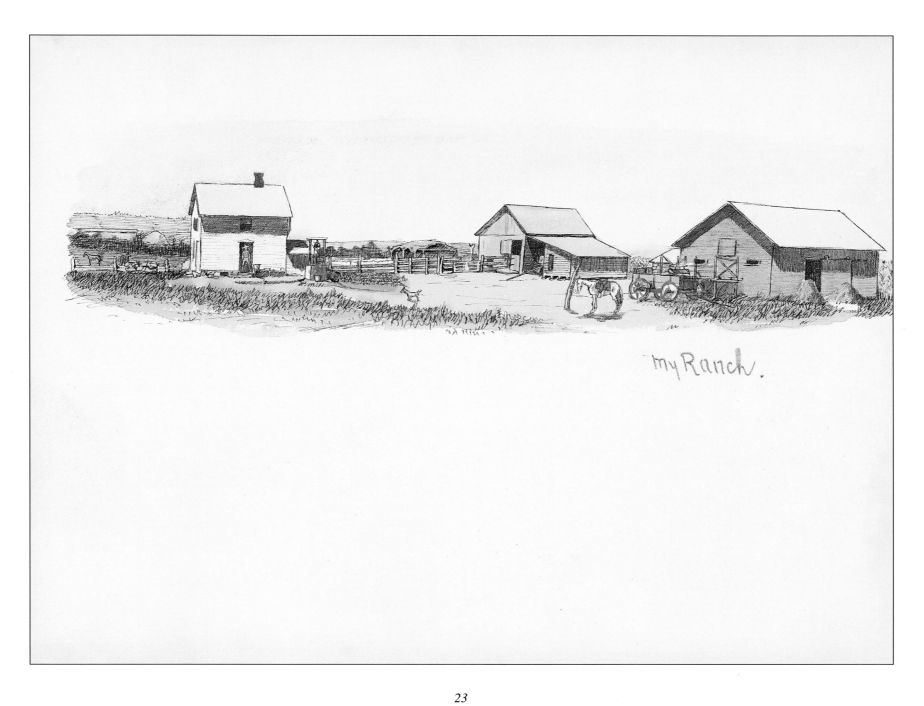

my Ranch.

A Peril of the Plains (1888-1889)
Gouache on paper. 18 x 24½ inches (45.7 x 62.2 cm).
Frederic Remington Art Museum, Ogdensburg, New York.

Traditionally, such horses did not have names. They were referred to by physical characteristics such as colouring or markings, or by their place of origin. A horse might be 'the bay' or 'that horse from the Bar-Q Ranch', but was never given a personal name. In this context, Remington's Terra Cotta would have been regarded as a very strange horse indeed.

Remington gradually built up his ranch, increasing it both in size and numbers of animals. He was enjoying himself as never before; he was his own boss and could do pretty much as he pleased. Generally this involved sketching, drawing and talking to the old timers who remembered the plains in the days when they truly were the last outposts of the frontier. Settling easily into the life of a rancher Remington seems, however, to have delegated much of the actual work of running the place to his staff.

In the early autumn of 1883, Remington's Uncle Lamartin arrived in Kansas on a visit to his nephew's ranch. Remington was keen to show off his property and new lifestyle. No doubt he was eager to prove to his uncle that coming out West had been a successful move. His sketches and drawings would, no doubt, have been displayed though Uncle Lamartin may have been more interested in examining his nephew's accounts and prospects for the future. While out on the range one day, the two Remingtons were caught in one of the ferocious squalls of rain which cold winds can trigger off on the grasslands in autumn. Uncle Lamartin caught a severe chill which he seemed unable to shake off. He caught the train back to New York, but failed to recover and died before Christmas.

Kansas was already an official state at this time and the frontier had moved on. In its day Kansas had been among the wildest and most turbulent areas of the West. It had gained its name 'Bloody Kansas' in the 1850s when pro-slavery gangs warred openly with abolitionists and the Kansas territory had a reputation for boisterous lawlessness. In 1855 Missouri had passed a law banning Texas cattle from being driven through its land during the summer for fear of a disease known as Texas fever. As a result the cowboys driving herds north had diverted to march across what was then Kansas territory. Along their route they met a few settlers. Among these was the famous John Baxter who stood 6 feet 7 inches tall, ran a saloon and had four daughters. His saloon at Baxter Springs was to become one of the first Kansas cow towns. Dodge City came later, reaching a peak of success when it boasted a saloon for every 60 residents.

By the time Remington came to Kansas, the state had begun to settle down. Having become a state in 1861, Kansas had opened up to farmers in the wake of the Civil War. By 1875 the cattle were being loaded on to trains further west and north. In fact Kansas had become so settled that its population density was about the same as modern Wyoming. Remington was moving into a relatively law-abiding state.

Many others seeking frontier opportunities were moving on. For some reason many family men, working in trade and food supplies, moved out of Kansas to settle in the new towns. One cowboy, writing of the 1870s, reported: *'There never was a cow town which did not have a family including "them girls from Kansas",*

and their fame was sure to be known abroad all over the local range. One by one the girls from Kansas disappeared down the road of matrimony, yet still the supply seemed unexhausted: more girls from Kansas coming in some mysterious way.' For some reason, less respectable girls all seemed to come from Texas or the Carolinas.

In truth, Remington was less of a frontier rancher and more of a gentleman farmer. Such men were not unusual on the plains. The business of ranching demanded a high capital investment by the 1880s. The days of picking up mavericks was long gone, as was the custom of turning a blind eye to a bit of rustling by a young cowboy who got married and wished to set up on his own. By Remington's time, good hard cash had to be paid out for stock, equipment and even for land. It was also becoming the custom for men to remove their hats and guns at a dance, generally reckoned to be a sure sign of civilization.

Although Remington was still very much an Easterner, not yet fully assimilated into the life of the plains, his quick eye did not fail to notice what was going on around him. Although he rode a part-thoroughbred himself, he faithfully sketched the cow ponies. He refused to get involved in gunfights, but spoke to those who had and made careful drawings of their guns, clothes and equipment. He did not run cattle, but observed those who did and noted their tools and techniques. He was building up an impressive store of knowledge of the ways of the West, even as it was vanishing before his very eyes.

But sheep farming was neither as profitable as Remington had expected, nor as safe. One old cowboy recalled that when sheep entered a territory where they were not welcome, trouble would follow. *'The solitary sheep herder, sitting with head downcast, might hear the sing of a bullet. He might take the hint, or again receive the final hint and go "over the range", never more to return. The sheep, sometimes driven into some box canyon or defile, were butchered in hundreds and thousands. One sheep outfit, if memory serves correctly, lost nearly four thousand sheep one afternoon in a little canyon where they were crowded up.'*

It is unlikely that the threat of frontier violence finally persuaded Remington to abandon sheep ranching, for Kansas was a rather more settled place by that time. More probable was the lack of profit from his business which encouraged Remington to quit, together with his undiminished desire to become a full-

U.S. Cavalry Officer in Campaign Dress of the 1870s (1901)
From a portfolio of 8 colour photolithographs published as 'A Bunch of Buckskins'.
Pastels. 15 x 20 inches (38.1 x 50.8 cm).
Peter Newark's Western Americana.

time artist. Whatever the case, he sold his ranch in May 1884 and headed for Kansas City, Missouri. It is thought that Remington took a small loss on the sale of his ranch.

Remington got out of the sheep trade only just in time. The trouble simmering between cowboy and sheepman was about to erupt into open warfare. In 1886, the famous Tewkesbury range war broke out. In Arizona a great swathe of cattle country was divided between two families, the Grahams and the Tewkesburys, who were on decidedly bad terms with one another. In 1886 the Californian sheep company of Daggs Brothers hired the Tewkesburys to run sheep for them in Arizona.

When the Tewkesburys brought their sheep in, the Grahams called a conference of cattlemen at their ranch. Not only did ranchers and cowboys turn up, but so did a number of outlaws and lawmen, for once united. It was decided to demand that the Tewkesburys leave under threat of violence. When they refused, the shooting began. Sheepherders were murdered and sheep driven over cliffs. In reprisal, two of the Graham brothers were shot dead and several cowboys gunned down. The trouble was not restricted to Arizona. Hearing of the open warfare, cattlemen elsewhere became bolder in their persecution of the sheepmen.

Eventually, in February 1887, the Daggs Brothers pulled out. The fighting meant that they could not turn a decent profit from their sheep. But the trouble was far from over. Resentments still lingered in Arizona. It was not until 1892 that the final shoot-out occurred when the last Graham brother was shot down by Ed Tewkesbury. Tewkesbury later died in prison before he could be hanged.

The most notorious of the sheep range wars was over. But it served to provide inspiration for Remington, busily attempting to produce works of sufficient commercial appeal to earn himself a living. Then the dramatic events of the Arizona range war began to grab the attention of the public at large and Remington was able to capitalize once again on his talent for depicting the West as it really was.

The Cow Puncher (1901). *Oil on canvas. 28⁷⁄₈ x 19 inches (73.5 x 48.3 cm). Sid W. Richardson Collection/Peter Newark's Western Americana.*

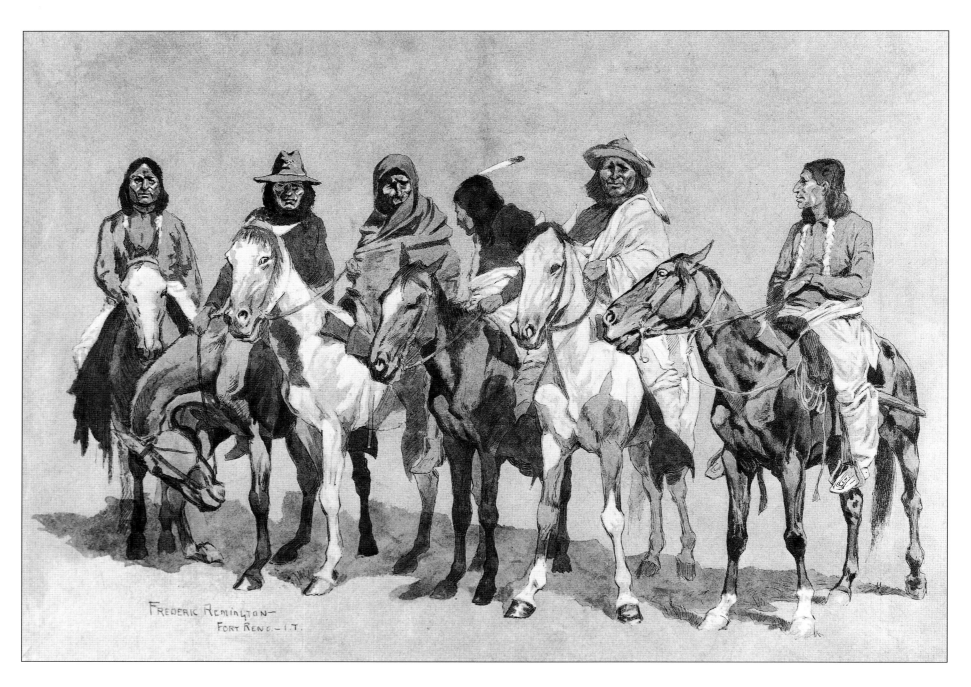

Chapter Three
Artist of the Range

Having spent a year as a sheepman in Kansas, Remington clearly felt the need for a more settled existence. The next few years were to see the somewhat footloose young man become a respected, if not yet prosperous, artist based in New York. But first Remington had to experience one last encounter with the old West.

He sold up his ranch and moved to Kansas City, Missouri in the spring of 1884. He found that the city had outgrown its cow town origins and had acquired a veneer of civilization and respectability. Although most streets were still mud or dust, depending on the weather, the buildings were equipped with boardwalks to keep pedestrians clear of the mire. Many residents with aspirations to gentility had a small cart or trap in which to travel round the town and to nearby settlements. Property and land were rapidly bought and sold as the city grew and over a million dollars changed hands each month.

Arriving in Kansas City, Remington found that he was spending much of his time in Bishop & Christie, one of the more respectable saloons. He reasoned that if he liked a place, others would like it too, and invested about $7,000 in the saloon. Strictly speaking, Bishop & Christie would have been termed a hotel by cowboys or cattlemen passing through its doors. The difference between establishments had little to do with the facilities on offer and everything to do with the pretensions of the owner. A hotel was decidedly a grade above a saloon, itself rather better than a cantina.

The first great hotel on the plains was the Drover's Cottage, built in Abilene,

Kansas, in 1868. It was later enlarged to have 100 rooms with stabling for 50 wagons and 100 horses and one of the most luxurious bars in the West. Hotel bars

PAGE 28
Waiting for the Beef Issue (1889)
Pen and ink wash on grey paper. 24 x 18^{1}/$_{4}$ inches (61 x 46.3 cm).
Frederic Remington Art Museum, Ogdensburg, New York.

PAGE 29
Norman Percheron (1890)
Ink wash on paper. 10^{1}/$_{2}$ x 12 inches (26.7 x 30.5 cm).
Frederic Remington Art Museum, Ogdensburg, New York.

LEFT
Full-Dress Mexican Engineer (c. 1889)
Oil on academy board. 28^{1}/$_{2}$ x 19 inches (72.4 x 48.3 cm).
Frederic Remington Art Museum, Ogdensburg, New York.

OPPOSITE
Small Oaks (1887)
Oil on canvas. 11^{3}/$_{4}$ x 13^{3}/$_{4}$ inches (29.9 x 34.9 cm).
Frederic Remington Art Museum, Ogdensburg, New York.

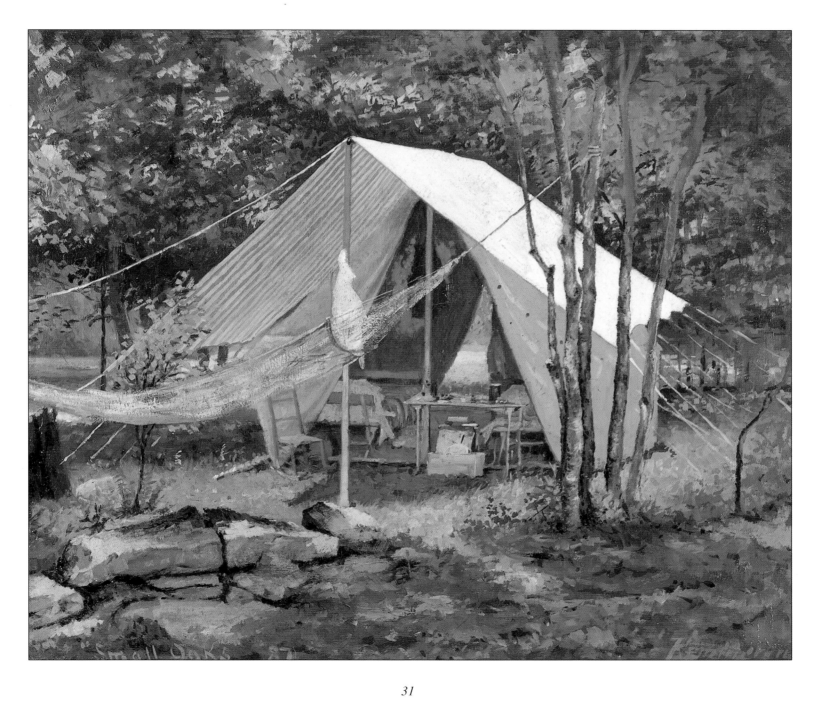

Frederic Remington·
Fort Sill. I. Ty.·

A Comanche (c. 1889)
Ink, gouache and wash on paper. 18$\frac{1}{4}$ x 17$\frac{1}{4}$ inches (46.4 x 43.8 cm).
Frederic Remington Art Museum, Ogdensburg, New York.

Page 34
Texas Cowboy (c.1890)
Oil on canvas.
Private Collection/Peter Newark's Western Americana.

PAGE 35
'Turn Him Loose, Bill' (c. 1885)
Oil on canvas. 25 x 33 inches (63.5 x 83.8 cm).
Anschutz Collection, Colorado/Peter Newark's Western Americana

featured chairs, tables and entertainments of various kinds. With rooms costing $1.50 a night, these hotels were aimed at the cattlemen who owned ranches rather than the cowboys who worked them. Each of the great cow towns had its hotel; Dodge House in Dodge City, Beed's Hotel in Ellsworth and Douglas House in Wichita.

Saloons were altogether less expensive and less comfortable places. Chairs and tables were only provided for card and dice games and the bars tended to be plain wooden affairs. An early photograph of the Longbranch Saloon in Dodge City shows a long narrow room, white-washed throughout, the bar occupying most of one side. Over the bar hang a pair of longhorns and a rather sentimental family group, perhaps to remind the cowboys of the homes they had left behind.

One early traveller who went out West to buy cattle described the saloons he visited: *'They were jerry-built affairs with hardly a cellar. The lumber used often warped badly, being more or less green. The structures stood propped up one or two feet above ground. Each had a front flare on which the owner boldly painted the name of his place. Everything was dirty and smelly. The blend of tobacco, liquor, straw, horses, kerosene and sweat left an unforgettable odor.'*

The only drink generally available was whiskey. It was cheap to produce, cheap to transport and, unlike beer, kept well enough to survive transport. There were a great number of brands available, with most large towns having a distillery to produce a cheap local version, usually of inferior quality. Such local liquor was referred to contemptuously as 'Kansas sheep dip' by the cowboys, but they drank

it all the same. However, the more discerning might choose brands such as Old Crow or McBryan, brought in from the mid-West.

The saloon in which Remington invested his money was more of a hotel. It looked to the townsmen of Kansas City for most of its custom, though its position ensured a steady stream of travellers. In the summer, Remington left Kansas City to travel home to New York. There he renewed his courtship of Eva Caten. This time he was successful and gained the approval of the Caten family. The wedding took place on 30 September 1884, and the very next day the happy couple departed for Kansas City.

Despite the various trappings of civilization which existed in Kansas City, its wealth remained cattle-based. The southern branch of the *Union Pacific Railroad* passed through on its way to Denver and en route close to Dodge City, then at its peak as a cow town, as well as several other towns which by this time were in decline. The city was in some ways ideal for the young Remingtons. It was sufficiently stylish and sophisticated to keep Eva happy and close enough to the West to ensure a steady supply of stories and travellers to amply feed Remington's imagination.

No doubt many of the colourful Western characters passing through Kansas City would stop at Bishop & Christie for a drink and a bite to eat. Remington liked to meet them there to chat about events out West and make careful sketches of their clothes, equipment and appearance. In fact, Remington seems to have spent a great deal of time in the bar just talking to the various drifters and

travellers who passed through.

These travellers would have had much to tell the eager young man – Remington was still only 23 years old. One newspaperman visiting the Kansas cow towns wrote: *'On the north side of the tracks you are in Kansas, and hear sober and profitable conversation on the subject of the weather, the price of the land and the crops. When you cross to the south side you are in Texas, and talk is about cattle, varied by occasional remarks on "beeves" and "stocks". Nine out of ten men you meet are interested in the cattle trade; five at least out of every ten are Texans.'*

But most of the stories Remington heard related to the saloon business in which he was engaged. One cowboy remarked of the Kansas towns: *'Though the church might be tolerated, the saloon and dance hall were regarded as necessities. In the early days it was a regular and comparatively innocent pastime to "shoot up the town". To shoot out the lights of a saloon was a simple occupation, and to compel a tenderfoot to dance to the tune of a revolver was looked upon as legitimate and pleasing diversion such as any gentleman of the range might enjoy to his full satisfaction.'*

One such exuberant arrival of cowboys in town became the subject of one of Remington's most famous bronzes, produced in 1902. Originally entitled *Coming Through the Rye* (page 74), the work was variously known as *Shooting Up the Town* or *Off the Trail*. The work shows four cowboys riding into town, firing their pistols into the air, after a long cattle drive. Remington managed to construct the work so that one of the horses is completely airborne as it prances forward. The original bronze stood over 30 inches (78.4 cm) high and became one of his most celebrated pieces. The work was later reproduced, larger than life, to adorn the entrance to the Lewis and Clark Exposition in Portland, Oregon, in 1905. Sadly, the giant plaster cast has since been lost.

Such triumphs still lay in Remington's future. His only artistic success in 1884 was to sell another sketch to *Harper's*. Again the work was redrawn by a staff artist, this time Thure de Thulstrup, but Remington was again credited. The picture was entitled *Ejecting an Oklahoma Boomer*, another depiction of the rough-and-ready Western world which Remington had readily absorbed from tales of the Kansas cow towns. However, the acceptance of the work was a great

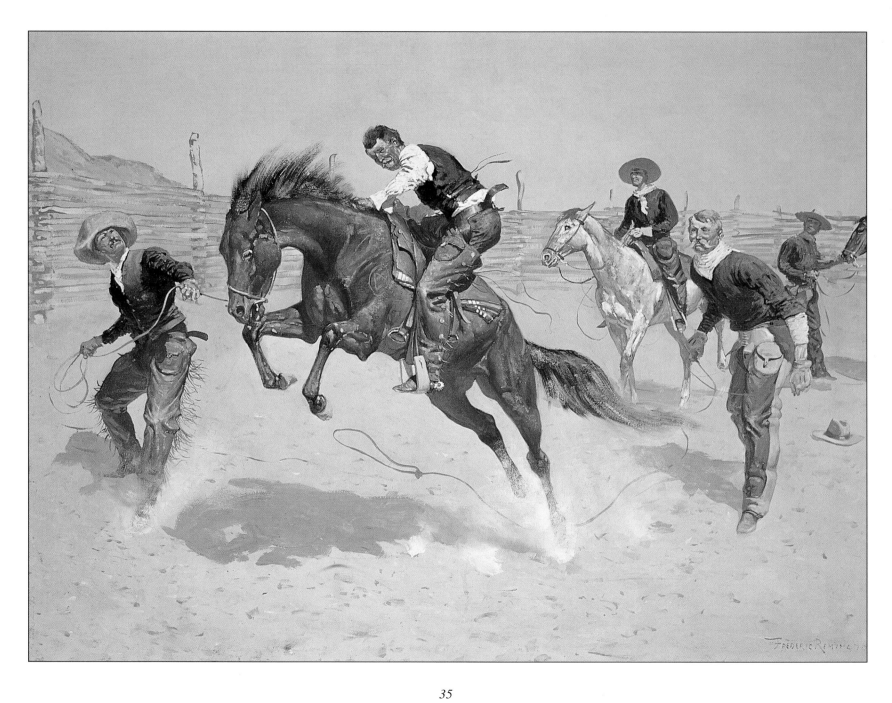

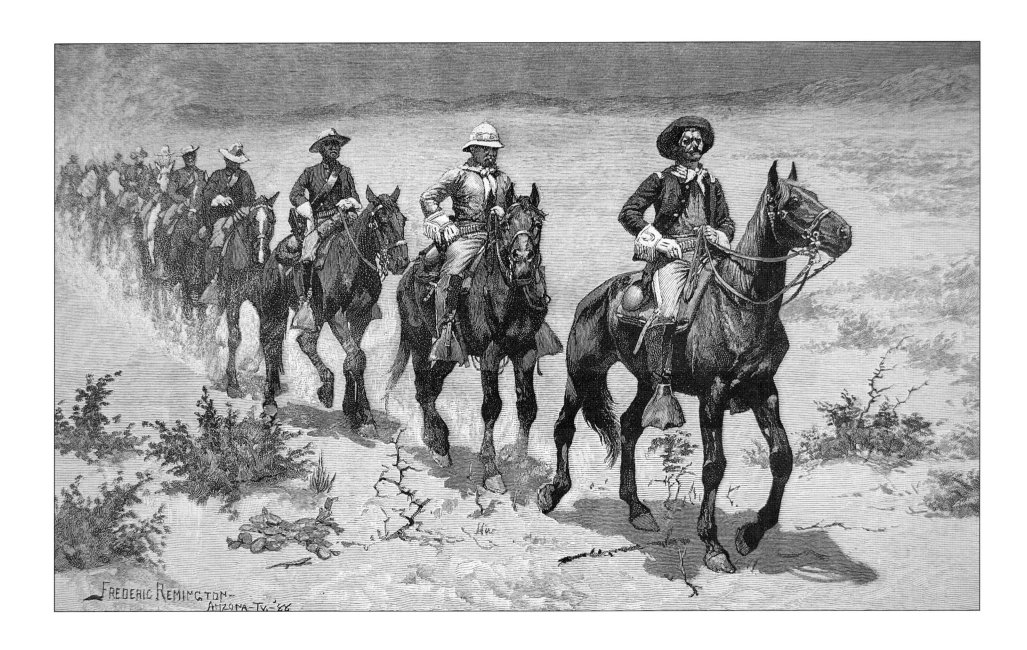

LEFT
**On the March with the U.S. (Negro) Cavalry Regiment
(Remington second in line wearing the sun helmet.)**
Engraving published in The Century Magazine *of April 1889.*
Peter Newark's Western Americana.

RIGHT
A Sergeant of the U.S. Cavalry (1890)
Engraving after a drawing from life.
Peter Newark's Western Americana.

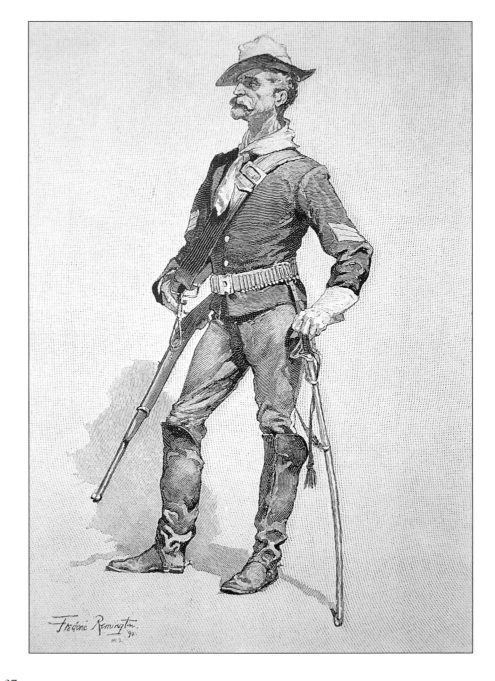

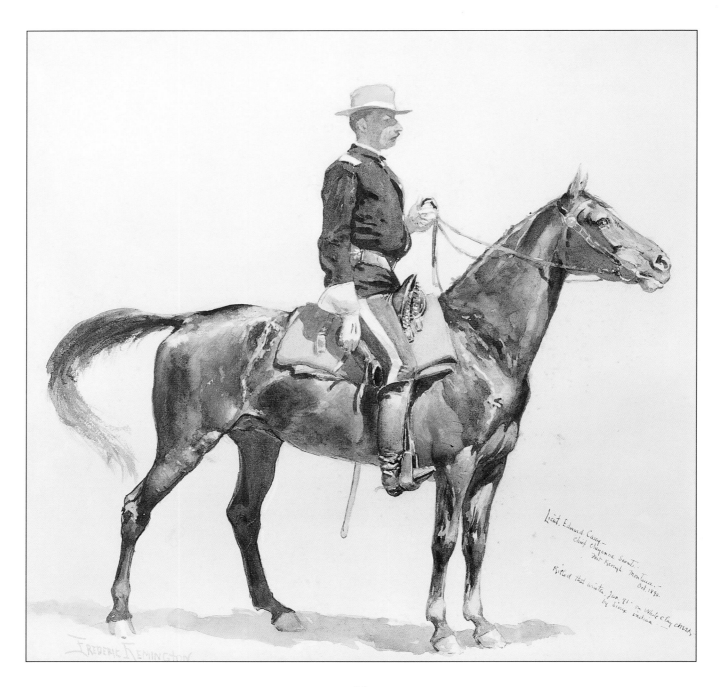

Lieut. Edward Casey
chief cheyenne Scouts
Fort Keough Montana
Oct. 1890.

Killed that winter, Jan. 91 on White Clay Creek
by Sioux Indian

Frederic Remington

Lieutenant Casey, Commandant of Cheyenne Scouts (1890)
Watercolour on paper. 16¼ x 17 inches (41.2 x 43.2 cm).
Frederic Remington Art Museum, Ogdensburg, New York.

encouragement to Remington. He was still in contact with Eastern publishers and this gave him hope for greater success in the future.

As Remington depicted in his sketch, heavy drinking inevitably led to argument and it was hardly surprising that violence was the end result. He would undoubtedly have heard of the legendary night in Newton, a few miles along the rail line from Kansas City, when eleven men died in a single day.

A Texan gambler named Bill Bailey was killed in a drunken brawl by a Newton local called Mike McCluskie. A drove of Texas cattle led by Hugh Anderson was nearby at the time. When the cowboys learned that a fellow Texan had been killed, they rode into town to exact revenge.

The cowboys found McCluskie in the Tuttle Dance Hall. Without warning, Anderson shot McCluskie who fell wounded. At that moment, McCluskie's friend Jim Riley walked in. He promptly turned, locked the bar doors, and began shooting. The ensuing carnage ended only when no one was left standing and the sheriff managed to smash down the doors to get in and arrest the wounded survivors. 'Bad Night in Newton' became an epic legend of the West, passed by word of mouth from one end of cattle country to the other. Twenty years after the event, garbled versions of the shoot-out were still being related to newcomers from the East.

Remington himself later drew on such wild tales to illustrate his work. The pen-and-ink drawing of 1897, *Them Three Mexicans is Eliminated,* depicts a fight in Woodville, New Mexico. Like Bad Night in Newton, the encounter was already

a legend when Remington made use of the subject. Sheriff Mace Bowman had shot a Mexican robber from Chilili. Three of the robber's friends rode into Woodville looking for Bowman. They found him in Anna's saloon and drew their guns. Bowman shot all three dead. In Remington's picture the dusty New Mexico saloon is faithfully portrayed, as is the dress of both the Mexicans and Bowman. Other drinkers dive for cover while the bar-keeper raises his hands in surrender.

But not all high jinks ended in bloodshed. In Dodge City in the late 1870s, a cowboy got drunk and rode into town. *'This cowpuncher,'* a fellow cowboy recorded, *'rode his horse into the saloon and up to the bar, declaring that both he and the horse had come a long way and were thirsty. He then began to shoot around a little, and drove everybody out of the saloon except one cattle man who still stood quietly leaning on the bar. The cattle man stood there saying nothing and finally the cowpuncher rode on out. When asked why he had not driven out the "old man" he replied that he had not seen him. "You could shore of seen him if you looked hard," said a friend, "fer he was right at you there in the middle of the room." As a matter of fact the reputation of the "old man" was such that the cowboy was very wise in not seeing him and undertaking to run him out.'*

In a vain attempt to reduce the incidence of such violence, gambling, one of the main causes of violent argument, was outlawed. The law was enforced at Remington's bar in Kansas City and in a few nearby townships, but was widely ignored in the cow towns. Every bar in Dodge City offered gambling, usually card games including poker, faro and monte, or dice games such as keno. A few of the

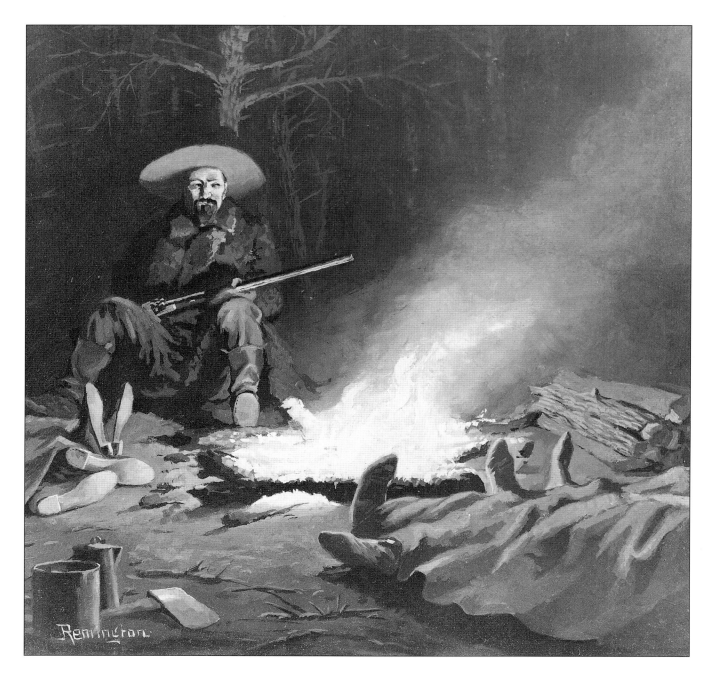

larger saloons and hotels had staff to run the games, but most just let their customers play among themselves. It was in the latter that the professional gamblers made their living, winning hands down from cowboys and drifters.

Games were played fast and furiously and with as much as a month's wages changing hands on the turn of a card, trouble was inevitable. A contemporary of Remington reported on an evening in Ellsworth for *The Kansas Nationalist*. *'I was walking down the street from supper. I heard three shots fired and saw a man rush out of a saloon and up the street with a six-shooter in each hand. He ran about half a block and fell. Everyone rushed to the spot and every second man you met had a revolver in his hand. Finally the result was ascertained to be one man shot through the arm, another man shot through the leg and a third with only a hole through the pants' leg. The first two did the shooting. Both are gamblers and the whole thing arose over a game of monte. The third man was a spectator, and the shot that just missed him clearly unintentional, and should be a lesson to him to loaf in some better place.'*

Such encounters were later sources of inspiration for Remington. In a colour engraving *Dispute over a Deal*, he shows a cowboy standing up and grasping his pistol while his fellow gamblers make conciliatory noises. An army corporal lounges nearby, apparently unconcerned. His later ink wash, *Misdeal*, portrays the aftermath of a dispute over a card game. Five cowboys, identifiable by their chaps and boots, have been playing cards. One is slumped over the table, his hands grasping for the disputed pot of money. A second lies dead on the floor while two more sprawl wounded. The fifth cowboy stands shakily by the table. The bar-keeper is reaching for a shotgun, too late to restore order, while curious onlookers peer warily through the door. It was the kind of scene often recounted to Remington, though there is no record of any such violent dispute at Bishop & Christie.

Disputes there were, however. In March 1885, the saloon moved premises. For some reason, Remington's investment was not properly protected by legal contracts. It was claimed that the new premises were not a part of Remington's stake and he lost most of his money. The complexities of the affair were never fully explained and Remington made no attempt to take his former partners to law to recoup his investment.

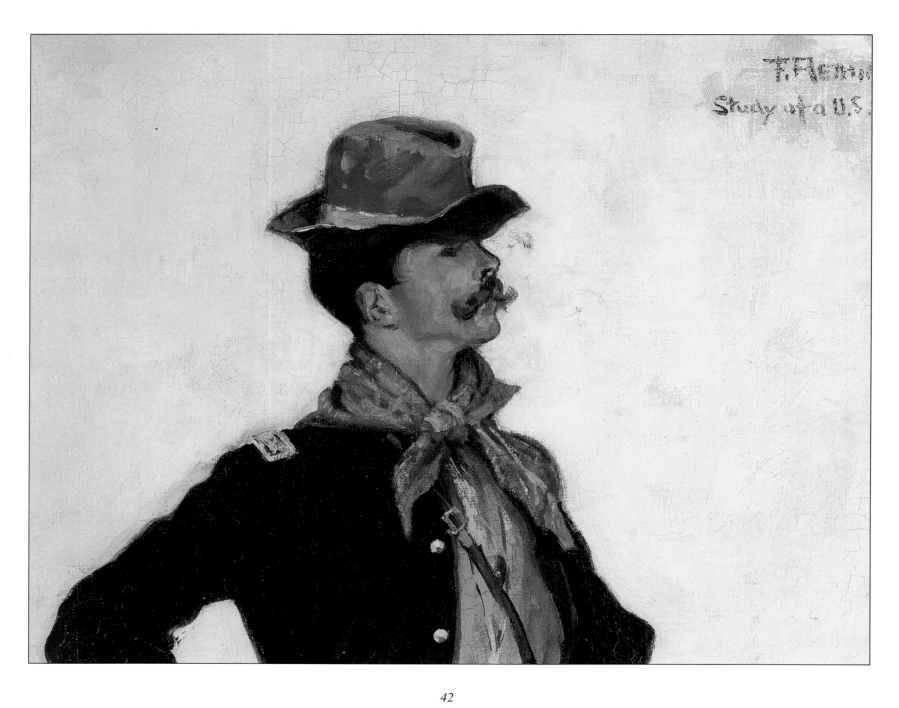

42

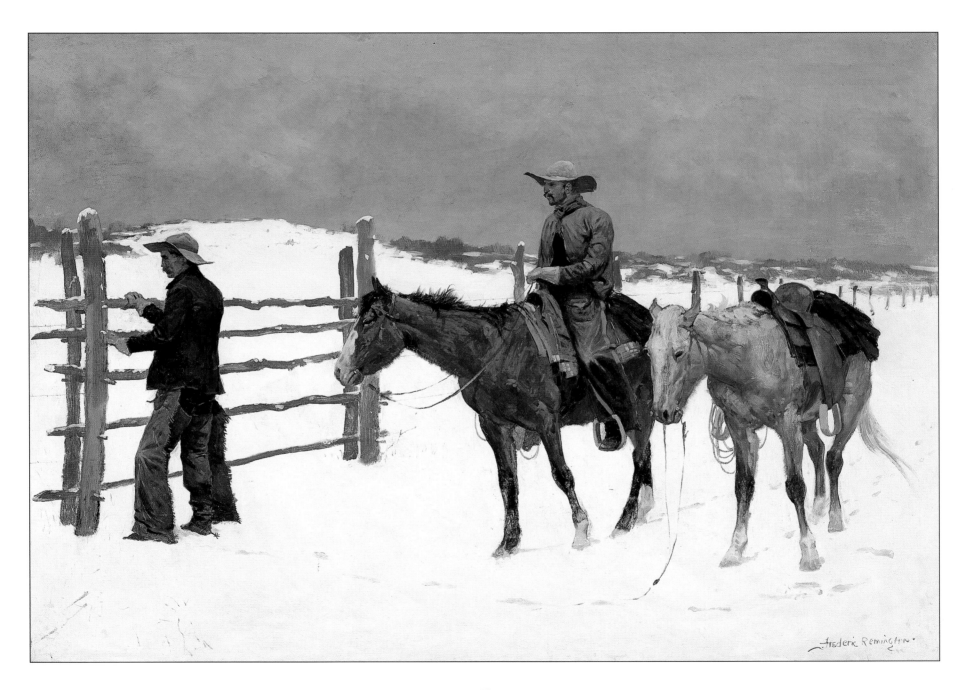

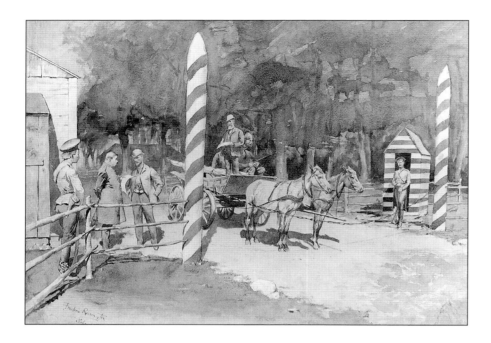

ABOVE
The Frontier Guard and Custom-House (1892)
Ink wash on paper. 22 x 30 inches (55.9 x 76.2 cm).
Frederic Remington Art Museum, Ogdensburg, New York.

OPPOSITE
Water – Cavalry Watering their Horses (1892)
Pen and ink wash and gouache on paper. 18 x 30½ inches (45.7 x 77.5 cm).
Frederic Remington Art Museum, Ogdensburg, New York.

PAGE 46
Banff (Cascade Range) 1890
Oil on academy board. 30 x 18 inches (76.2 x 45.7 cm).
Frederic Remington Art Museum, Ogdensburg, New York.

PAGE 47
On the Trail (1889). *Oil on canvas.*
Private Collection/Peter Newark's Western Americana.

Instead, he sent his new wife home to her family while he set off on a tour of the western plains. His stated aim was to gather more material and sketches for his work. However, he had as yet sold only two sketches, both of which had been reworked, so there could only have been faint hope of financial reward from such a trip. The reaction of Eva's family, as she arrived home to report the loss of her husband's money, has not been recorded. But it can be well imagined.

The West in 1885 was undergoing a period of profound change. Events in Canada and Montana grabbed the headlines, but with hindsight the changes to the XIT Ranch in Texas had more long lasting effects.

The trouble in Canada had begun the previous year when the *métis*, French-native Canadian half-breeds, had requested the political agitator, Louis Riel, to negotiate with the government over disputed land claims. Poor crops in 1884 made the situation worse as famine and poverty threatened the *métis* and other farmers of the western prairies. The government set up a Royal Commission to decide their claims but Riel decided to force the pace.

On 26 March he led a band of fighting men against the North-West Mounted Police. Riel attempted to gather the tribes together to join his *métis*, but they generally preferred peace to war and only a few warriors joined him. In May the Canadian army smashed the rebels. Riel was captured, but many *métis* escaped and fled to Montana in July. There were some anxious months on the northern range while the *métis* and their leader, Gabriel Dumont, waited, armed and sullen in their camps. Then Dumont joined Buffalo Bill's Wild West Show and his followers dispersed.

Further south, the state of Texas handed out a massive 3 million acres of grazing land on the Panhandle to Taylor, Babock & Company as payment for building the new state capital of Austin. The stretch of land was named the XIT Ranch and the new owners decided to protect its boundaries against encroaching farmers or rival herds by erecting a fence. The fence was made of barbed wire and stretched for 780 miles (1255 km). It cost $181,000 to erect and needed 300 railroad cars to haul the wooden posts and barbed wire to site.

The utilization of barbed wire was to mark the end of the old West. At the time, however, it did not seem that way. Fences were nothing new on the open range. They were used when counting and rounding up the herds, and especially

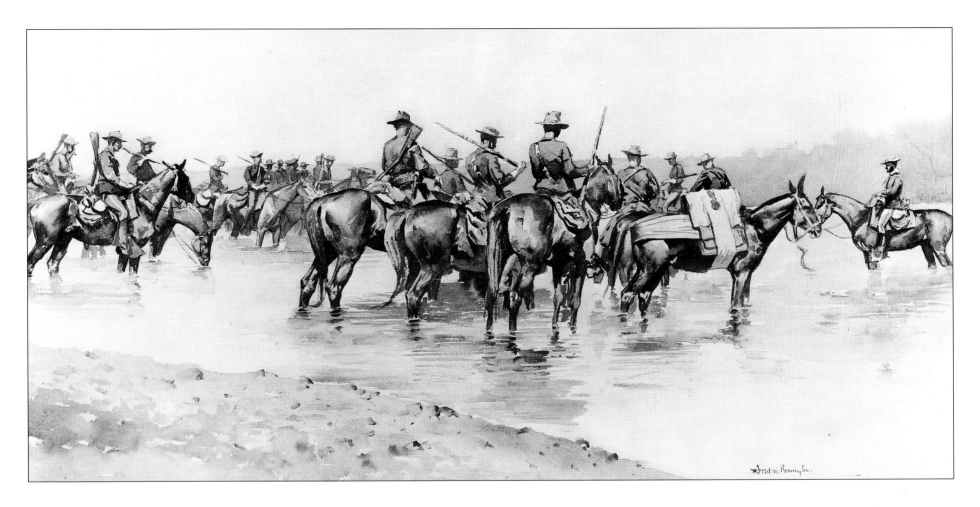

in horse work. The earliest barbed wire fences had appeared in the late 1870s. They were erected by farmers and 'nesters' to protect their crops from wandering longhorns. The cattlemen approved, at first, as the new fencing finally put an end to irritating claims by farmers that cattle had trampled crops, and to the demands for compensation that followed.

There could be no doubting the effectiveness of barbed wire in controlling stock. Will James, then a cowboy in Texas, recorded that '... *beefs would run full tilt right into it, and many of them got badly hurt; and when one got a scratch*

sufficient to draw blood, worms would take hold of it. After three years of wire fences, I have seen horses and cattle that you could hardly drive between two posts, and if there was a line of posts running across the prairie, I have seen a bunch of range horses follow the line out to the end and then turn. But in a few years, the old tough-hided cow found a way to crawl through into a corn field if the wire was not well stretched and the posts close together.'

So effective was barbed wire at keeping cattle out of farmland that demand rose rapidly. In 1874 five tons of barbed wire was sold. By 1880 that figure

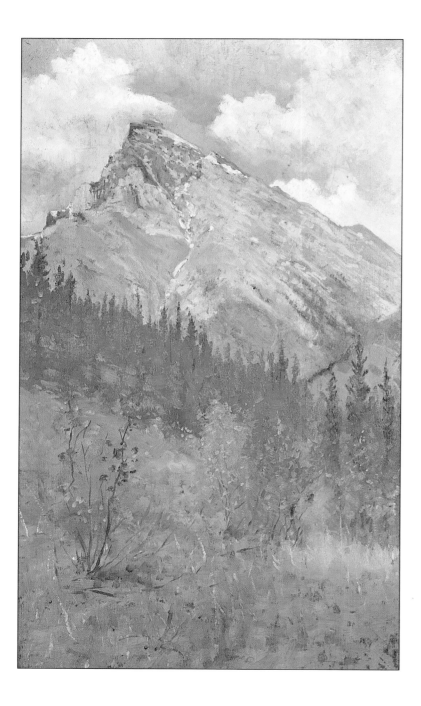

had risen to 40,200 tons and by 1880 the cattlemen themselves were using barbed wire. At first these were simple 'drift fences', running east-west to prevent cattle drifting south in the winter. This habit of cattle caused great annoyance at the spring round-up when ranchers had to ride many miles south to collect their wayward animals. By 1882 some ranchers were using homesteading laws to their own advantage. They would pay cowboys to stake a homestead around a water-hole, then buy it from them and fence it in. Water rights were vital on the open range. By securing the water supply it was possible to keep out farmers who needed irrigation for their crops.

Such piecemeal enclosure of the open range was already destroying the old ways of cattle ranching even before the advent of the mass fencing of the XIT Ranch. In 1884, a Texas trail boss let rip his exasperation in an Eastern publication: *'In 1874 there was no fencing along the trails to the North, and we had lots of range to graze on. Now there is so much land taken up and fenced in that the trail for the most of the way is little better than a crooked lane, and we have hard times to find enough range to feed on. These fellows from Ohio, Indiana and other states have made farms, enclosed pastures and fenced in water-holes until you can't rest. They are the ruin of the country. It makes me sick to think of it. I am sick enough to need two doctors, a druggery, and a mineral spring when I think of onions and potatoes growing where mustang ponies should be exercising and where four year old steers should be getting ripe for market. Fences, sir, are the curse of the country.'*

When the XIT found it could raise fine quality cattle by carefully parcelling out pasture, rather than allowing longhorns to run wild, the days of the old range were numbered. The winter of 1885 proved to be one of the very worst on record. Temperatures plunged to 42 degrees below zero in February, accompanied by vicious gales. Hundreds of thousands of cattle froze or starved to death. That winter and the following financial crises effectively destroyed the old cattle industry. The future belonged to what were effectively cattle farms rather than open range ranches.

It was that vicious winter that first brought fame to a Western artist, a rival to Remington for public acclaim and recognition. A young cowboy named Charles Marion Russell was working for the Bar R ranch in Montana when a message

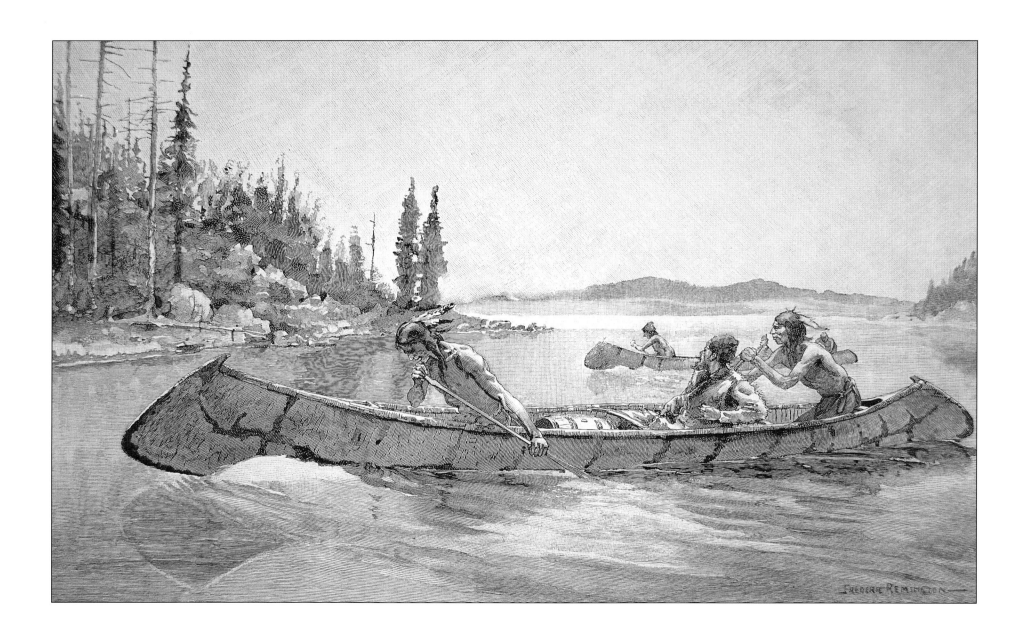

Fur Traders in Canoe: Rival traders racing to the Indian camp
Engraving published in Harper's New Monthly Magazine *of February 1892.*
Peter Newark's Western Americana.

came through from the ranch owners asking for news of their 5,000 head of cattle. Instead of sending back a written report, Russell quickly sketched a starving cow in the snow watched by coyotes waiting for it to die. Russell wrote *Waiting for a Chinook* under the picture and sent it off. The ranch owners were depressed to receive such bad news. But they retitled the work *The Last of 5,000* and began to sell prints of it. Charlie Russell was set on his road to fame and fortune.

Remington, meanwhile, had again managed to get out just in time. He left the plains before the really bad weather set in. He travelled north-east to his family in Canton, pausing only briefly before arriving at the Caten household in Gloversville. The reception accorded to the young Remington was not overly warm. He had, after all, married the Caten's beloved daughter, lost most of his money and sent her home, only to embark on a jaunt around the West. Remington lost little time in packing up his few belongings and moving with Eva to New York.

The young couple were running short of money. They rented rooms on 9th Street in Brooklyn which would not have met with the approval of their grander relatives and would almost certainly have been regarded with horror by Uncle Lamartin. Still seeking to make his mark as a professional artist, Remington set out with his portfolio of Western sketches. He called at *Harper's* and at the offices of other magazines and journals, without success. Although most editors praised the integrity of his drawings and sketches, none felt confident enough to buy a picture or commission a new work.

As Remington trudged through New York, endeavouring to sell his work, he noticed how rapidly the city was changing. Just two years earlier the Brooklyn Bridge was opened amid great public rejoicing. At nearly 1,600 feet (488 m) it was the largest bridge of its kind in the world, tall enough to allow ships to pass beneath it. A few weeks before Remington arrived, the stunt man Robert Odlum had hit the headlines by jumping off it. It was as well that the bridge had been built, for Remington needed to cross the East river from Brooklyn in order to reach his publishers in Manhattan.

Another mighty structure beginning to take shape in New York was the Statue of Liberty. Inspired by a wonder of the ancient world, the Colossus of Rhodes, the statue was intended to be a symbol of hope to the masses of immigrants pouring into New York by ship. In the course of its construction, money for the pedestal ran out and a public subscription was raised in order to find the $350,000 needed.

Remington received some encouragement from other professionals. One of them suggested he take classes at the Art Students' League of New York to tighten up his technique. At this time the League was at the leading edge of art style and was highly respected for the technical abilities of its teachers and students. One of the teachers was Alden Weir, brother of the Yale professor John Weir who had taught Remington in 1879.

While attending the League, Remington's technical grasp of drawing and illustration improved enormously. Above all, he discovered that a career as a commercial artist involved far more than good draughtmanship. The League

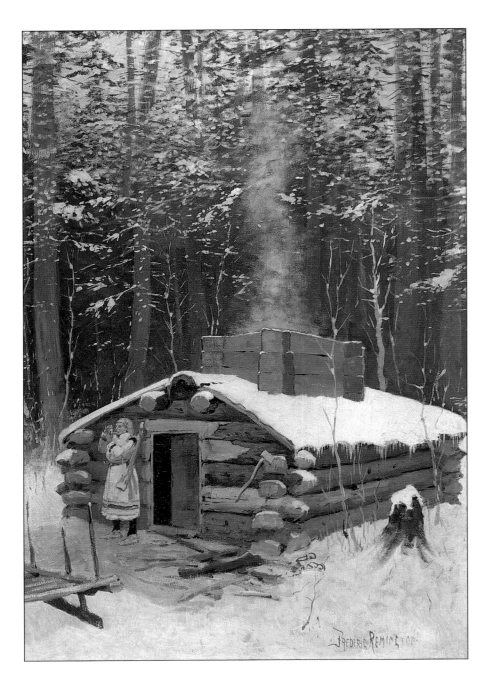

Cabin in the Woods (1889-1890)
Oil on canvas. 28$\frac{1}{2}$ x 20$\frac{1}{2}$ inches (72.39 x 52.07 cm).
Frederic Remington Art Museum, Ogdensburg, New York.

OPPOSITE
Bronco Buster (c. 1895)
Oil on canvas. 35 x 23 inches (88.9 x 58.4 cm).
Private Collection/Peter Newark's Western Americana.

thronged with old hacks and professionals, fugitives from journalism and publishing, who dropped in to catch up on the latest stylistic innovations. They discussed the tricks of their trade with Remington, and he was an eager pupil.

Among the first things Remington needed to learn were the technicalities of printing used by *Harper's* and other publications. At the time, virtually all illustrations were printed by means of wood engraving. The process involved the use of a hard wood with a very tight grain, for example, boxwood or teak. An engraver carefully scratched away the wood, using a selection of extremely sharp tools and a magnifying glass. This left a design of lines and blocks of raised wood. When the raised areas were inked and paper pressed on them, a clear and precise copy was duplicated.

Some artists specialized in the technique and one of the first to turn the medium into an art form was the Englishman Thomas Bewick. Born in 1753 he improved on the crude woodcuts used to illustrate cheap books, transforming them into works of extraordinary precision and clarity. Animals were Bewick's favourite subjects, whether in their natural setting or in books of fables. However, a greater influence on American commercial art of the 1880s was Gustave Doré. He arrived in Paris from Strasbourg in 1848, and took up where Bewick left off. He worked for high quality illustrated books, but also produced works of comedy and satire for magazines and periodicals. These were popular and widely circulated and would have been much admired at the League.

It was an unfortunate aspect of the technique of wood engraving that the blocks wore out and became smudged and indistinct after a few thousand copies. Although Doré and Bewick prepared their own blocks for short runs of high quality books, this was impractical for larger print runs when several blocks would be needed.

Instead, the artist would produce pen-and-ink drawings on thin paper. Small pin pricks would be made through the paper along the lines drawn by the artist and the holes used to make ink marks on a wooden block. The dotted block was then passed to a professional engraver who would scratch away the wood to produce a printing block. For larger illustrations, the picture would be cut into sections and each section engraved onto a different block, later to be joined together to produce the main printing block.

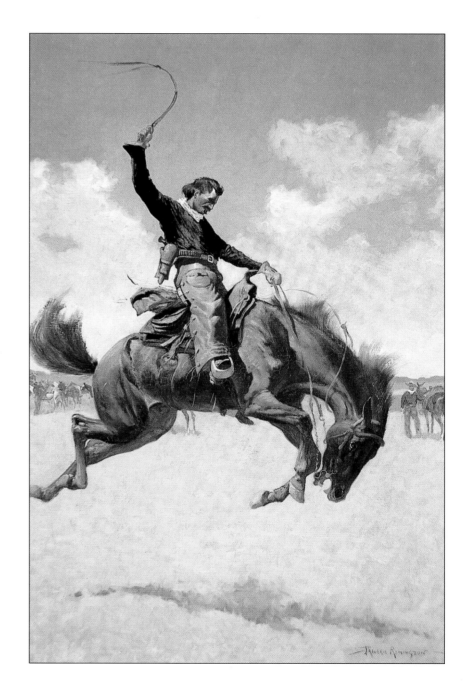

A good engraver was able to prepare a block which would accurately reproduce the original pen-and-ink drawing. However, the work of such craftsmen was expensive and most publications made do with the skills of lesser men. The limitations imposed on artists were considerable. Lines could not be too fine or less skilled engravers would be unable to reproduce them; shading was impossible, apart from crude cross-hatching, and many artists were chagrined to see copies of their work in print which were so inferior as to actively damage their reputations. Remington himself later expressed his disgust at the poor standard of reproduction of his own work, produced by the wood block technique. But in 1886 there was little alternative but to accept the situation as it was.

By May 1886, Remington had studied sketching, life drawing and painting at the League. The latter had captured Remington's imagination, but for the time being he concentrated on drawing and sketching. Clearly his work had improved enormously and consequently possessed more commercial potential. A trip to the offices of *Harper's* convinced the owner, Henry Harper, that Remington was an artist rapidly beginning to make his mark.

Remington was given a brief. He was to travel to the deserts of the south-west where the U.S. Army was engaged in a brutal war with the Apache and produce as many sketches and drawings as possible. Although *Harper's* did not undertake to publish all his work, there was sufficient encouragement to make the cost of the trip worthwhile. Remington packed his bags, artist's materials and diary and was on his way.

Shoeing Cossack Horses *(1892-1893)*
Pen and ink wash and watercolour on paper. 21 x 28$^{1/4}$ inches (53.3 x 71.8 cm).
Frederic Remington Art Museum, Ogdensburg, New York.

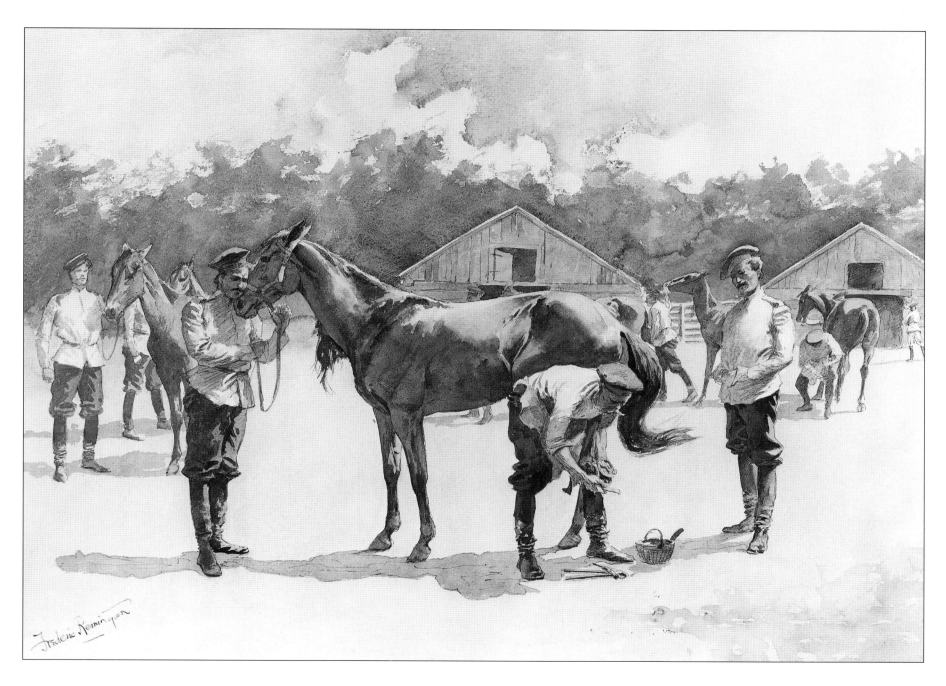

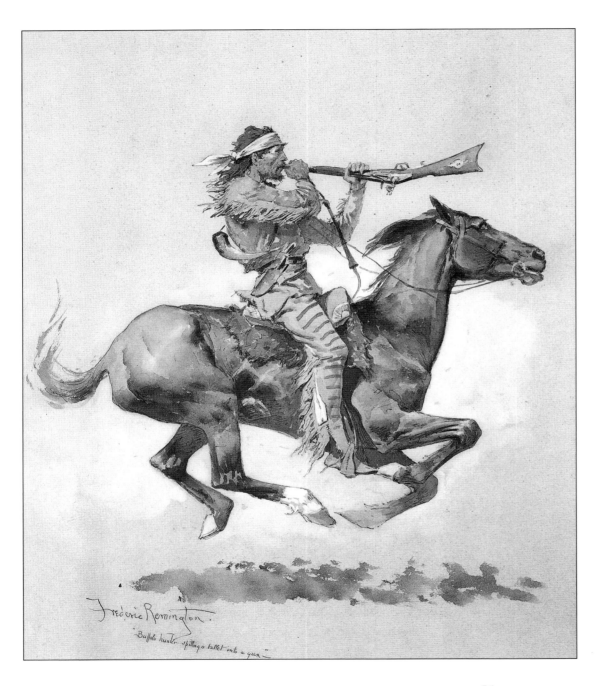

Buffalo Hunter Loading from the Mouth *(1892)*
Watercolour on grey paper. 17½ x 15¼ inches
(44.5 x 38.7 cm).
Frederic Remington Art Museum, Ogdensburg, New York.

OPPOSITE
Charge of the Rough Riders at San Juan Hill (1898)
Oil on canvas. 35 x 60 inches (88.9 x 152.4 cm).
Frederic Remington Art Museum, Ogdensburg, New York.
(See pages 100, 102)

PAGE 56
Captain Grimes's Battery Going up El Poso Hill (1908)
Oil on canvas. 26½ x 39¾ inches (67.3 x 101 cm).
Frederic Remington Art Museum, Ogdensburg, New York.

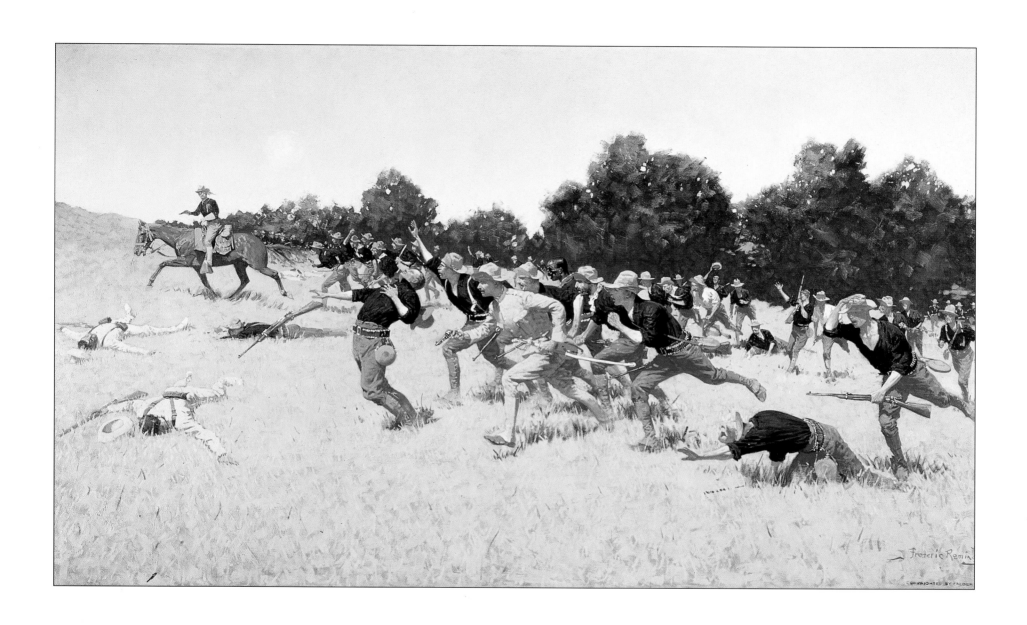

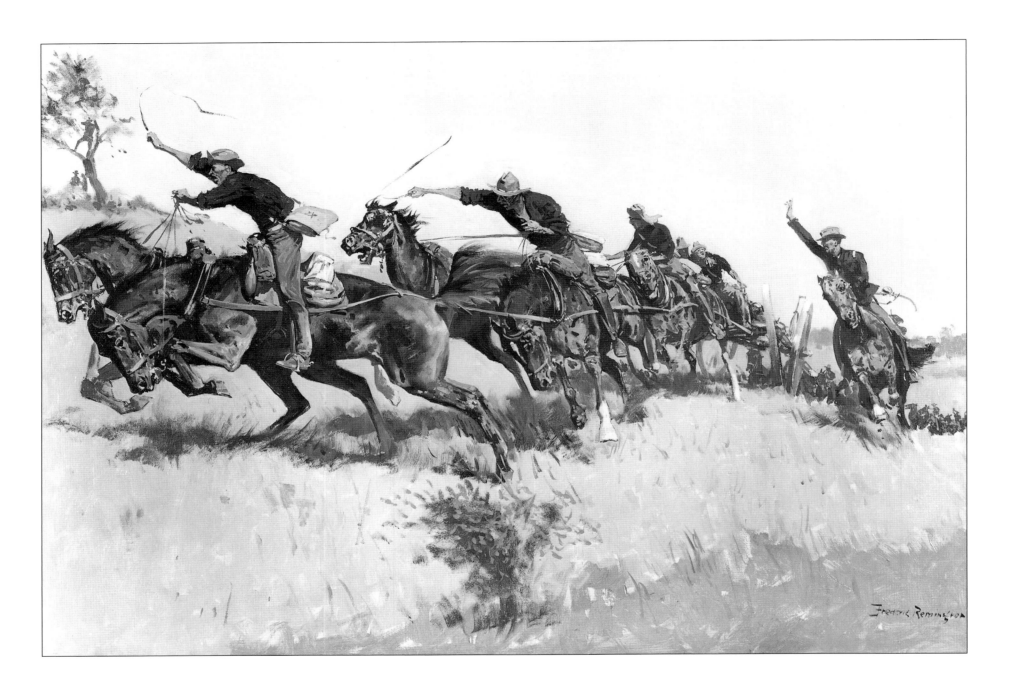

Chapter Four
Army Artist

When Remington set out to cover the Apache Wars for *Harper's*, he was venturing into unknown territory. His earlier wanderings had been to the great plains where cowboys and freighters reigned supreme. Now he was coming to desert country where the tribes still held a position of strength.

By 1886 the Apache Wars had been in progress, off and on, for almost 50 years. They were now entering their final bloody phase. The Apache were not a single tribe, but several. The name Apache did not originate from their own language but was a Zuni word meaning simply 'enemy'. The Apache considered themselves loosely bound by language and culture, but owed real loyalty to their individual tribes – the Mimbreno, Chiricahua, Mescalero, Jacarilla, Coyotero and others.

In 1870 it had been estimated that the combined tribes numbered around 6,000. Life in the desert had taught the Apache to be exceptionally hardy and patient. Outside the watered valleys where they grew squash, fruit and maize, the lands of New Mexico and Arizona were fit only for scattered herds of sheep stolen from Mexicans, or for hunting. The Apache tribes were only able to survive by raiding surrounding tribes for tribute and food. The boys were made to undergo rigorous training, a common ordeal being to run up a hill, their mouths filled with water, forcing them to breathe through their noses.

There appeared to be no limit to the endurance of the Apache. It was not unknown for a warrior to run 60 miles (100 km) a day and scarcity of prey in their desert environment made them experts at tracking, hunting and ambush. In times of war, the legendary ability of the Apache to suddenly vanish from sight was particularly unnerving to their enemies. The women, too, were trained to endure physical hardship. They were also adept at inflicting the most appalling torture and cruelty on prisoners taken captive by their menfolk.

Historically, the traditional arms of the Apache were bows, lances, clubs and knives, and they had special knowledge of poisonous plant juices with which to coat their weapons. By the time Remington arrived to chronicle the wars, they had acquired rifles. The tribesmen were, however, notoriously bad shots except at close range. This may have been due to the fact that it was difficult for them to acquire ammunition and they consequently received little practice. Many warriors preferred to retain their bows for fighting.

One U.S. Army officer, Captain John Bourke, who spent some years fighting the Apache wrote: *'No Indian has more virtues and none has been more truly ferocious when aroused. For centuries he has been pre-eminent over more peaceful nations about him for courage, skill and daring in war; cunning in deceiving and evading his enemies; ferocity in attack when skillfully planned ambuscades have led an unwary foe into his clutches; cruelty and brutality to captives; patient endurance and fortitude under the greatest privations.'* These were the enemies Remington went to draw. There can be little wonder they exerted such a profound fascination over him.

The war between Apache and white man began in 1837. The Mexican

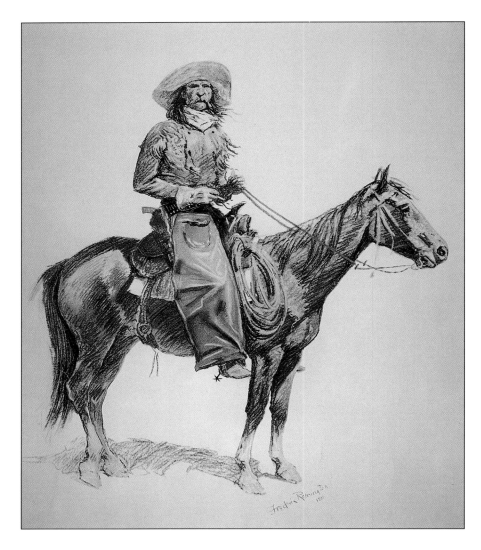

Arizona Cowboy in Range Dress (1901)
From a portfolio of 8 colour photolithographs first published as 'A Bunch of Buckskins'. Pastels. 15 x 20 inches (38.1 x 50.8 cm).
Peter Newark's Western Americana.
OPPOSITE
Apaches Listening (c. 1899). *Oil on canvas.*
Frederic Remington Art Museum, Ogdensburg, New York.

government had for some time offered a standard reward of $100 for each Apache warrior killed, $50 for a woman and $25 for a child. An American trapper named James Johnson decided to make a fast buck. He invited the Mimbreno Apache, a friendly tribe, to a feast at the mining camp of Santa Rita. When the large party of Mimbreno were full of food and drink, Johnson opened fire with two cannons. Over a hundred Mimbreno died with only a handful escaping.

One who did escape was a 6-foot-tall warrior who became known as Mangas Colorados, or Red Sleeves, from the red shirt which he habitually wore. Mangas was over 50 years old and an experienced warrior. He raised the entire fighting force of the Mimbreno and fell upon Santa Rita, the only man allowed to live being a priest who had befriended the Mimbreno. With this success behind him, Mangas had little difficulty recruiting warriors from other Apache tribes. The war of vengeance which followed laid waste much of what was then northern Mexico and drove Mexican settlers from the desert.

By 1852 the Apache lands had passed to the United States after a short war with Mexico and white prospectors and settlers began arriving in some numbers. The Apache were wary of the Americans with their superior guns and numbers. Peace lasted until 1860 when an unknown band of Indians raided a settlement and carried off a young boy as prisoner. Eager to preserve peace, Chief Cochise of the Chiricahua went to meet the cavalry under Lieutenant Bascom who had been sent to find the boy. Bascom misunderstood what Cochise said to him and ordered his men to arrest the chief and his party. Cochise escaped, but several of his men were killed. The Chiricahua went to war.

War spread throughout the Apache lands as tribe after tribe joined Cochise in his attempt to drive the Americans out as the Mexicans had been driven out 20 years before. The south-west was engulfed in a welter of bloodshed. By 1869 the Apache were still fighting, having driven out their enemy from great swathes of territory. General Sherman declared in exasperation: 'We had one war with Mexico to take Arizona, and now we should have another to make her take it back.'

In 1871 General Crook arrived to conduct the war. He abandoned attempts to exterminate the Apache. Instead, he lured them to reservations with promises of peace, teaching them to farm and keep stock so that there would be no further

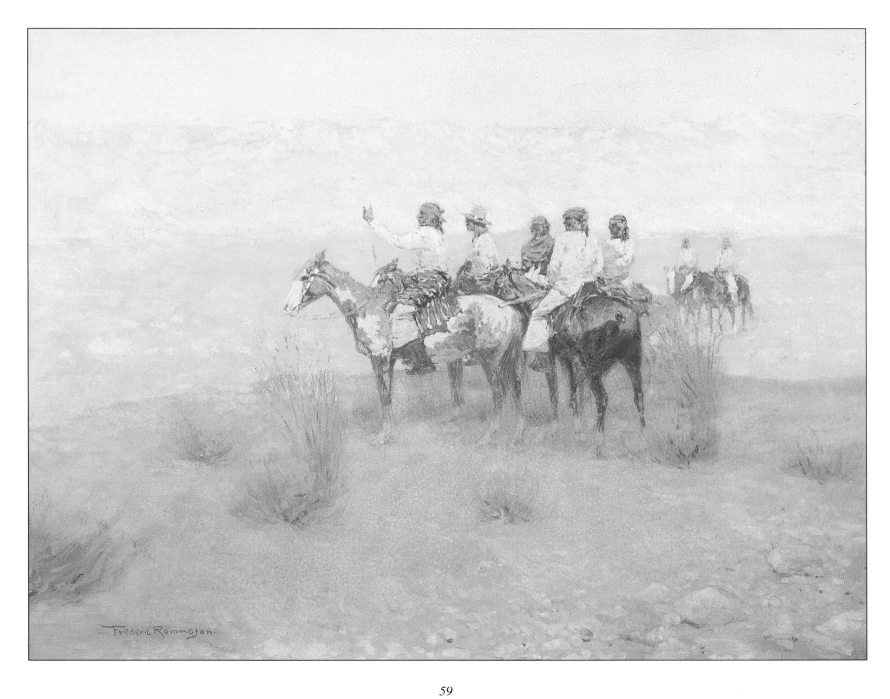

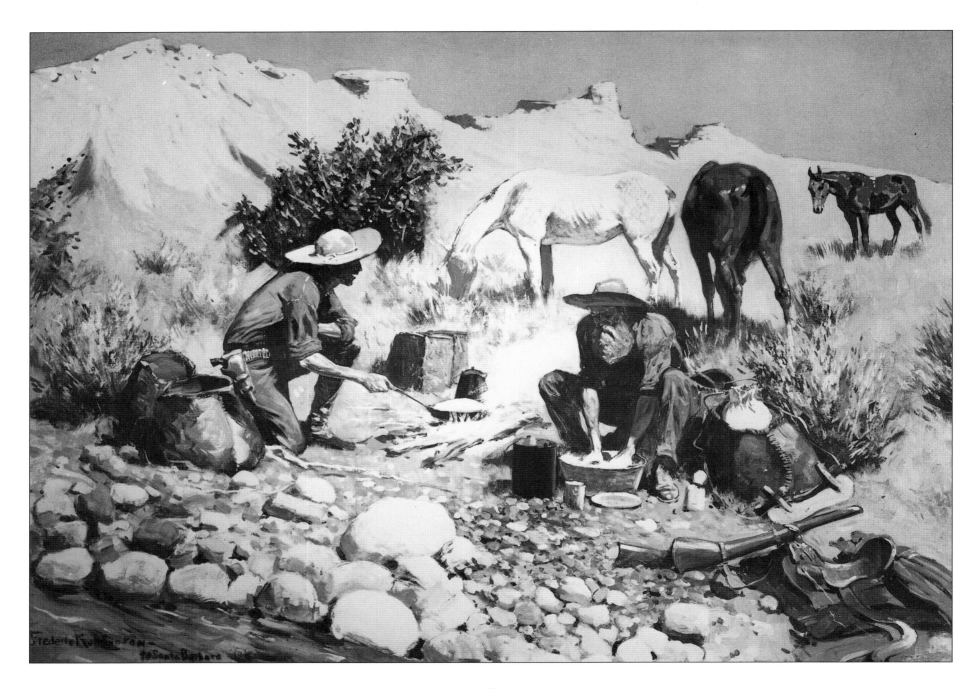

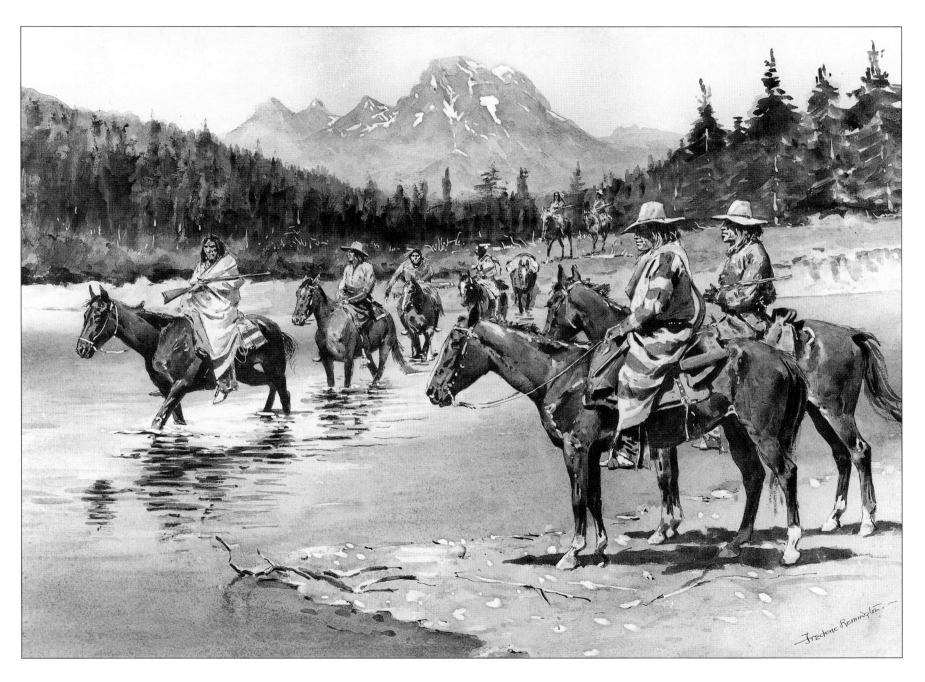

need to raid white settlers – even Cochise eventually opted for peace. But in 1879 Crook was replaced and the Apache were forcibly transported from reservations on their own tribal lands to a central camp at San Carlos. Conditions were appalling and many died of disease.

In May 1885, a medicine man named Geronimo broke from the confines of San Carlos with 17 warriors, 13 women and their children. It was rumoured and widely believed that Geronimo had taken a sacred vow that 'the next white man who sees my face is a dead white man'. A few months before, the chief Ulzana had departed accompanied by 11 men. Ulzana ambushed the cavalry troop sent to pursue them, killed 38 men, wiped out several settlements and vanished into the mountains. With Geronimo on the loose as well a dangerous situation was developing.

Remington arrived by way of St. Louis and at once set about getting to know soldiers and settlers involved in the war, surprised to find his old interest in the military way of life rekindled. His father would have felt immediately at home among the regimental discipline and indifferent horseflesh of the cavalry and Remington seems also to have relished the rough company.

One of the units he accompanied was the 10th U.S. Cavalry, a regiment of negroes. Having been on the frontier for some years, the regiment was well regarded by the high command and given some of the most remote patrols and outposts to man. Remington produced several spirited sketches of the regiment, including the famous watercolour, *The Riderless Horse.*

The history of this picture demonstrates the pitfalls awaiting the commercial artist at this time. Remington made a quick sketch on the spot, working it up into a watercolour later. He sent the picture back to *Harper's* for reproduction and it appeared in August 1886. Unfortunately, the wood block engraving was flat and lifeless compared to the original and Remington grew increasingly frustrated when he saw the way his work was being mutilated in the process of preparing it for publication.

Another sketch made during the Apache campaign was reworked as a watercolour before being published in *Harper's*. This picture, *The Ambushed Picket*, also of 1886, gives a clear indication of how the war was being fought. It shows a cavalryman being dragged along by his horse having been shot from ambush by an Apache. The soldier in the picture is white because the vast majority of the buying public back East was white and Remington overwhelmingly depicted white soldiers in his works. When he turned to the medium of oil and sculptures in bronze this tendency became even more pronounced. Clearly Remington knew his market-place.

The war dragged on as General Crook attempted to persuade the hostiles under Geronimo to return to the reservation. In the midst of these talks President Grant sent orders that only unconditional surrender would be accepted. Crook promptly resigned and was replaced by General Nelson Miles. Miles had no interest in persuading the Apaches to do anything and opted for a policy of extermination of Geronimo and his band.

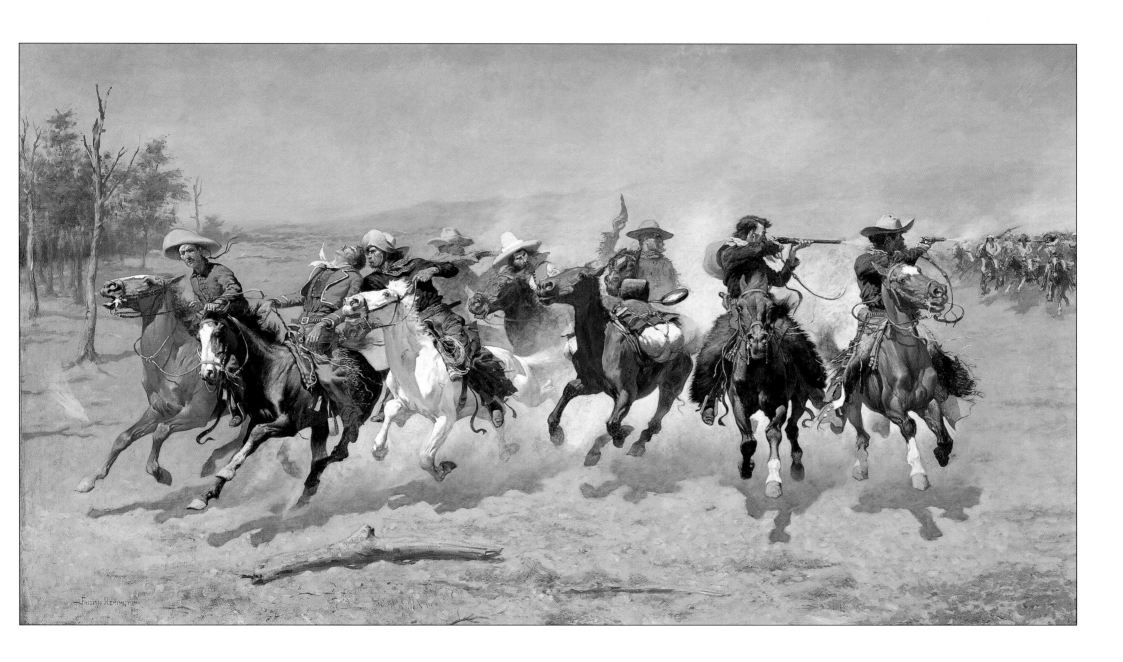

'Then He Grunted, and Left the Room' (c. 1894)
Ink wash on paper. 21$^{1}/_{2}$ x 21 inches (54.6 x 53.3 cm).
Frederic Remington Art Museum, Ogdensburg, New York.

Miles ordered his troops to occupy and guard every known water-hole in Apache country. The soldiers, and Remington, dubbed the new campaign 'The Waterhole War'. This prompted several of the more successful works Remington sent back East. *The Water in Arizona* shows a pair of Apache crouched beside a pool of water, fingering their rifles as three cavalrymen approach, unaware of the danger. The later *Fight for the Waterhole* is less obviously set in Arizona, but was no doubt inspired by Remington's experiences there.

This had little effect as Geronimo knew of water-holes the white man never suspected existed. A second tactic produced greater success. Miles equipped all his units with heliographs and gave them training in morse code. With this more immediate form of communication at their disposal they were able to concentrate their forces whenever Geronimo was sighted, reducing the need for exhausting patrols.

Although the casualties inflicted by Geronimo and his band were minor by Apache standards, his continued freedom was a great cause for concern. Civilians all across the south-west felt unsafe. Many fled, or sent their families to places of safety with relatives. The journals, including *Harper's*, demanded swift action and rapid results. Remington's sympathies were very much for the troopers engaged in the fighting and he was quick to point out the problems. *'Let anyone who wonders why the troops do not catch Geronimo,'* he wrote, *'but travel through a part of Arizona and Sonora and then he will wonder that they even try. Let him see the desert wastes of sand devoid of even grass, bristling with cactus. Let him*

see the sun pour down white hot upon the blistering sand about his feet and it will be plainer. Let him see a part of those jagged mountains and he can then imagine the whole for of course no one man has seen all the defiles and peaks of the Sierra Madres, as they rise into the blue above and sink in canyons dark and black.'

If Miles and his troops were beginning to feel the strain of constant campaigning, so was Geronimo. By the end of August he was willing to talk. Two of his women appeared at an army camp and made it known that Geronimo was ready to talk peace. Miles selected a young officer, Lieutenant Gatewood, who was popular with the Apache on the reservations and sent him to meet the famed medicine man.

Gatewood was required to enter the hostile camp alone otherwise Geronimo would have refused to talk to him. It must have been a terrifying experience for the young man to meet, face to face, the man who had eluded thousands of troops for months on end. Gatewood told Geronimo there could be no conditions. It was necessary for him to totally surrender or fight to the death. Geronimo went to consult with his men, leaving Gatewood to stand alone in the desert. Not until next morning did the Apache return to tell Gatewood they had agreed to surrender. Gatewood led them back to General Miles.

There is a famous photograph of the band of hostiles as they marched in to surrender. Chief Nana, the most senior Apache, rides a horse, while the medicine man Geronimo walks alongside. Spread out around them are the 24 men, women

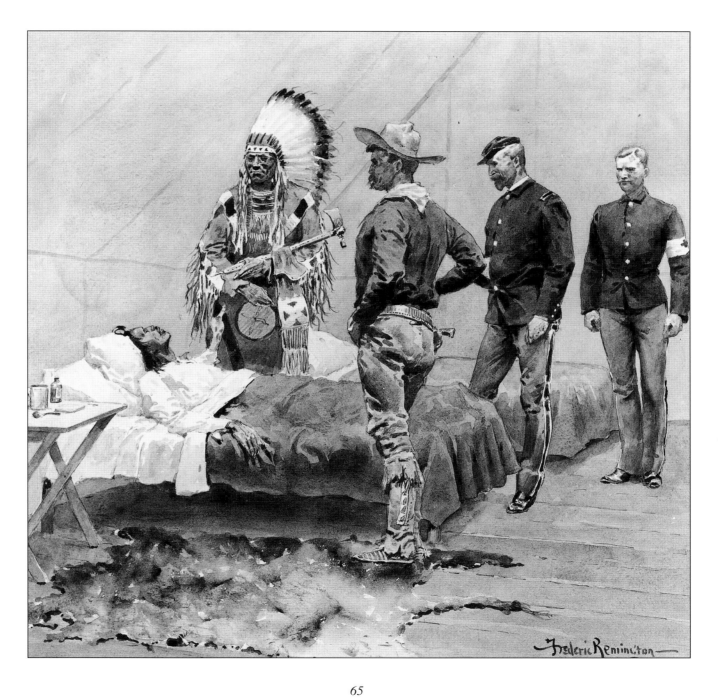

RIGHT
The Cheyenne (Modelled 1901, cast 1907). *Bronze.*
Height 21$\frac{1}{2}$ inches (54.6 cm).
Amon Carter Museum, Fort Worth, Texas.

OPPOSITE
The Wounded Bunkie (1896)
Bronze. Height 20$\frac{1}{4}$ inches (51.4 cm).
Amon Carter Museum, Fort Worth, Texas.

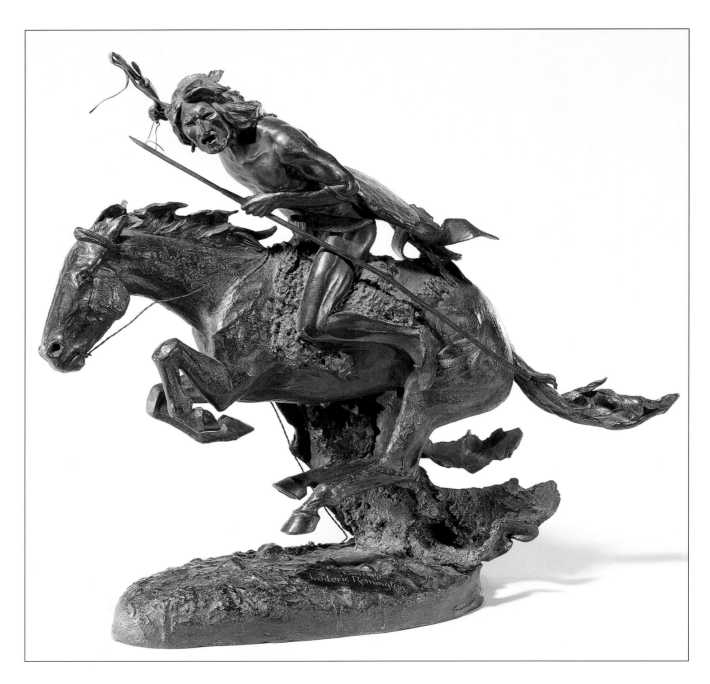

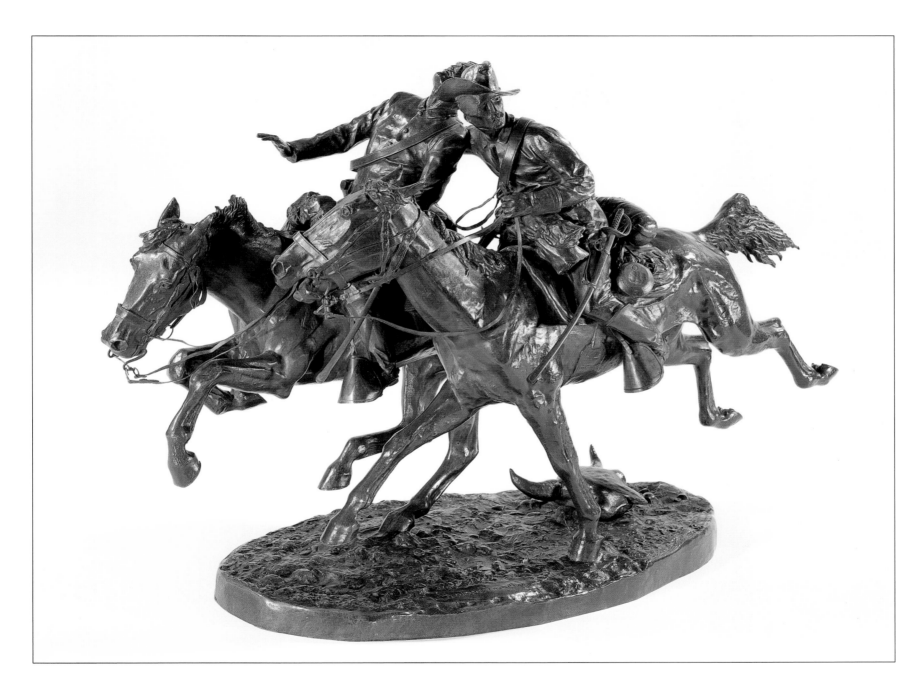

'My Second Shot Sent Him Lining Out After His Brother' (or) Indian Raid (1901)
Black and white, oil on canvas. 27¹/₄ x 40 inches (69.2 x 101.6 cm).
Frederick Remington Art Museum, Ogdensburg, New York.

and children of the band. The men carry rifles across their bodies while all appear ragged and tired. But somehow they manage to convey a pride and fierce defiance quite at odds with their humiliation.

With the war finally over, civilian life returned to normality. Military patrols were called off and travel became safer and more reliable. Remington pushed on south to reach Hermosillo in Mexico. His journey took him over the ranges of the Sierra Madre and into the valley of the Sonora. Here he was able to sketch the Mexican farmers and soldiers, also recently engaged against the Apache. Remington did not stay long, but obviously liked the area as he made it his business to return to paint it not long afterwards.

By November 1886 Remington was back with his wife in New York. *Harper's* had published several of the drawings he had made during the Apache campaign and Remington could at last boast that he was earning a living from his art. Eva must have been delighted that her husband was at last managing to establish himself, confounding the doubts of her family. That month the couple moved to more spacious rooms, still in Brooklyn.

Meanwhile, Remington was eagerly seeking work elsewhere. He spoke to agents of magazines outside New York, sending a portfolio of sketches to Chicago's *Illustrated Graphic News*, but gaining little from the exercise. He did manage to place some pictures in a children's magazine, but his big break came from the magazine *Outing*. The editorship of the magazine had been taken over by Poultney Bigelow, who had been at Yale with Remington. Once again, the

young artist's connections were proving useful in his chosen career.

Bigelow was looking for fresh new talent for his magazine. The moment he clapped eyes on his friend's work, he was jubilant. Remington's vivid commercial style captured the rough and tough of the south-west with astounding verve and a startling sense of immediacy. Moreover, it was suitable for reproduction using the new printing techniques. Bigelow later wrote of his feelings on seeing Remington's drawings: *'Here was the real thing, the unspoiled native genius dealing with Mexican ponies, cowboys, cactus, lariats and sombreros. No stage heroes these, no carefully pomaded hair and neatly tied cravats; these were the men of the real rodeo, parched in alkali dust, blinking out from barely opened eyelids under the furious rays of an Arizona sun.'*

He bought the lot.

Remington was fortunate in that *Harper's* star artist, Thomas Nast, resigned that year. This left a gap in the magazine's rota of artists waiting to be filled and Remington was among several others invited to supply artwork.

With the family finances finally on a steady footing, and orders for drawings coming in regularly, Remington could devote some time to developing his technique. His time at the League had fired Remington to take up colour work. His watercolours, completed during the Geronimo campaign, showed him to be more than competent in the medium. In the spring of 1887 Remington sent some of his paintings to the American Water Color Society for inclusion in their exhibition, one of the most highly rated in the country. The National Academy of

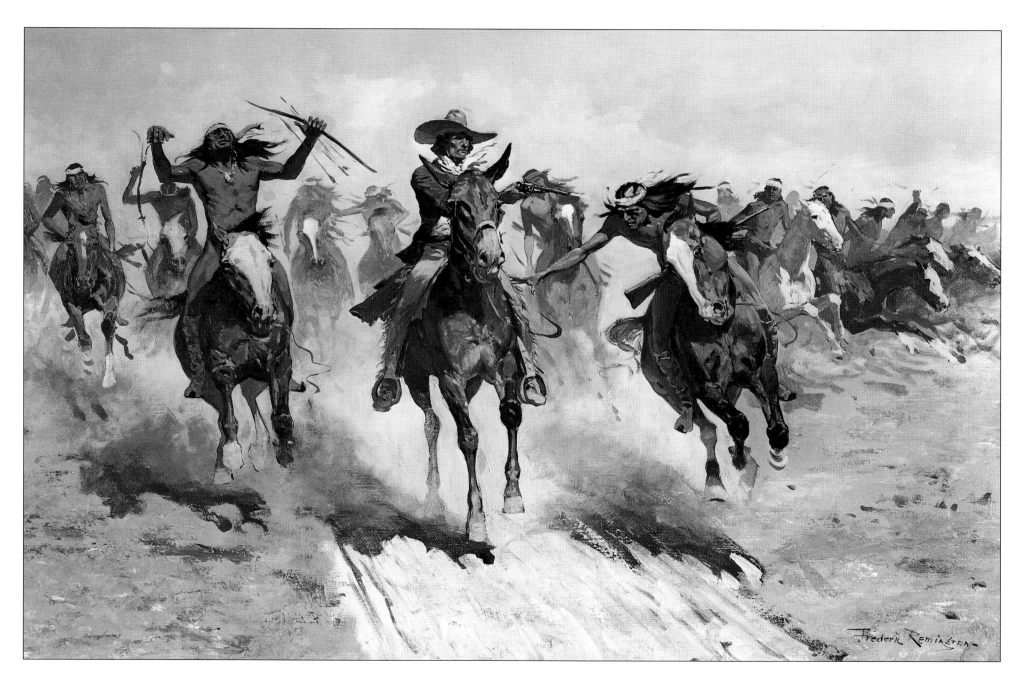

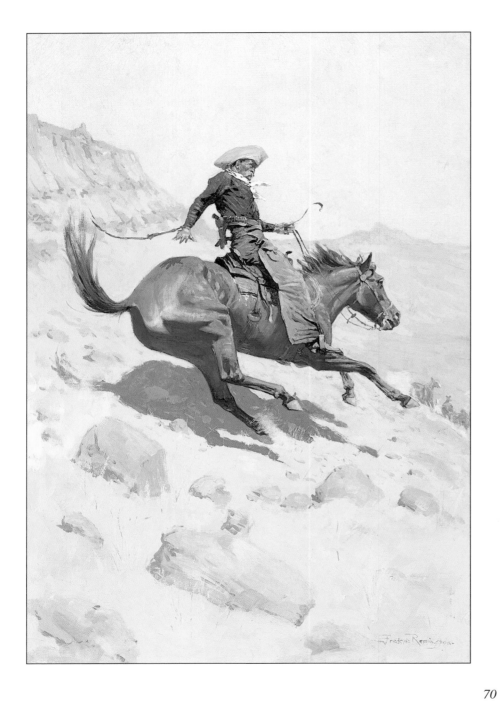

LEFT
The Cowboy (1902)
Oil on canvas. 40 1/4 x 27 3/8 inches (102 x 69.6 cm).
Amon Carter Museum, Fort Worth, Texas.

OPPOSITE
The Hold Up (c. 1900)
Oil on canvas.
Collection Valley National Bank, Phoenix, Arizona/Peter Newark's Western Americana

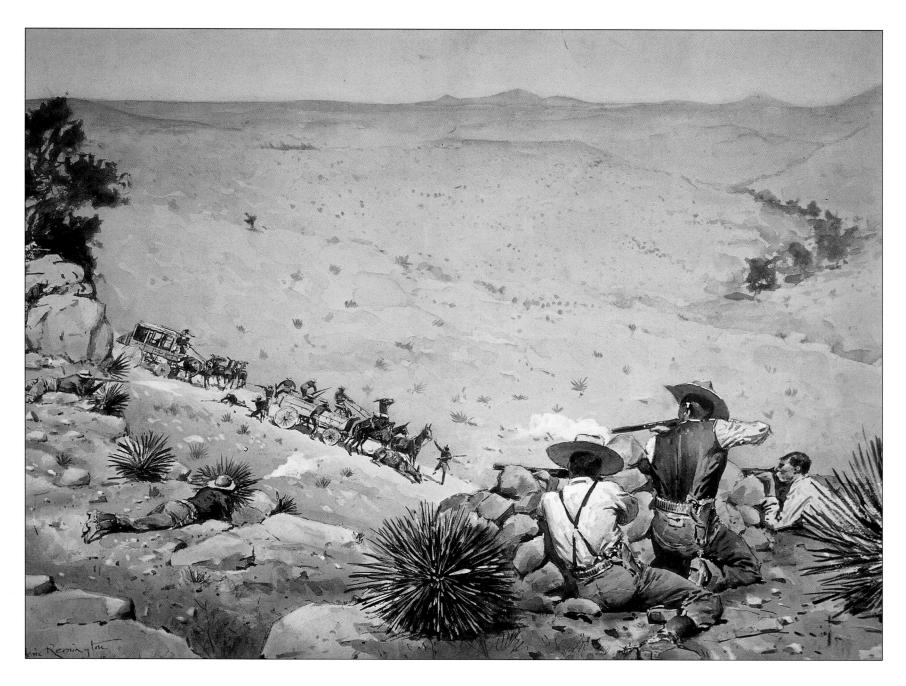

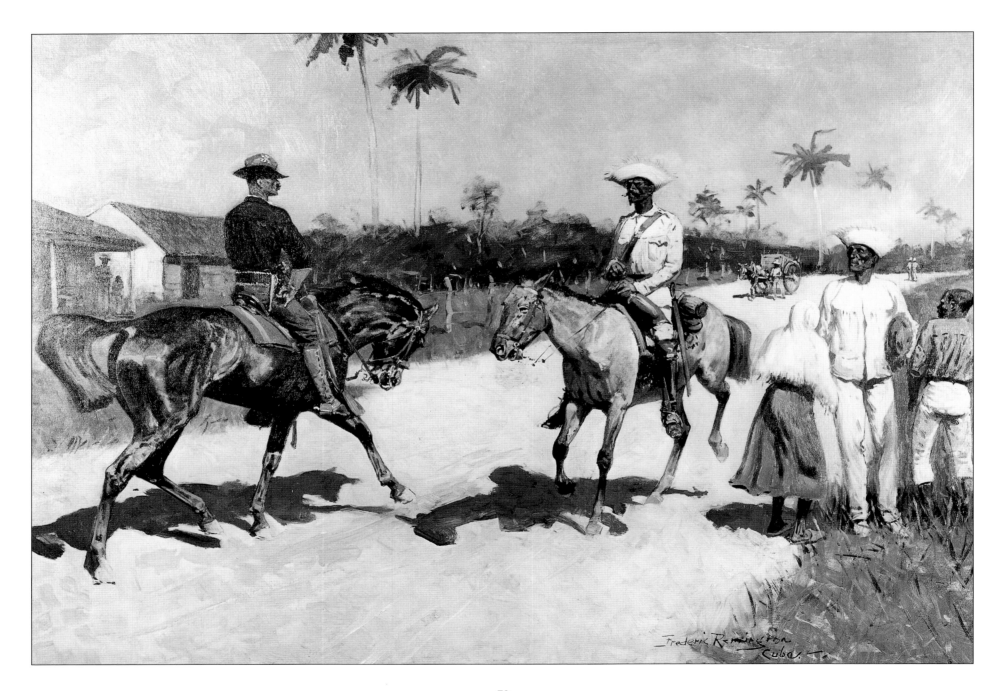

'Under Which King?' (1899)
Black and white, oil on canvas. 27 x 40 inches (68.6 x 101.6 cm).
Frederic Remington Art Museum, Ogdensburg, New York.

Design also took some of his watercolours and Remington was so delighted that he determined to attempt the progression to oils.

Meanwhile, he continued to produce drawings for the wood block engravers of various magazines. It is more than likely that Remington would have had a small collection of Western artifacts, such as saddles, boots and guns, which supplied the reference for his work: but he was keen to maintain total authenticity. In the summer of 1887 Remington headed out West once again. This time he travelled to the northern range as far north as Calgary.

On this trip Remington gathered material and made sketches of local tribes and farms. This proved to be fortuitous. That October, a gang of Crow jumped the reservation in Montana to pursue a feud with the nearby Piegan tribe. When the 20 warriors returned to the reservation they found themselves charged with horse stealing by the Crow Agent, Henry Williamson. Like other agents, Williamson was working towards the integration of the tribesmen under his charge into mainstream society. Part of his task was to persuade the warriors to take up farming and obey local territorial laws. He had had great success with the farming side of the programme, but the raid on the Piegan was a serious breach of the peace.

Even if the raid itself could be called run-of-the-mill, what happened next was not. Unknown to Williamson, the 20 braves were not just out on a raid. They were under the influence of a powerful medicine man named Swordbearer. This charismatic figure had proved himself exceptionally stoical during the self-torture

of the mystic sundance and had therefore acquired the reputation of being under the inspiration of the Great Spirit. When he declared that he was on a sacred mission and that his holy shirt was impervious armour, the warriors believed him. Swordbearer refused to surrender to Williamson and opened fire. His followers joined in the fight as Williamson scrambled for cover, then rode off into the mountains of Montana.

Harper's invited Remington to produce a picture of this dramatic incident and he responded by producing an oil painting on board. With his customary accuracy, Remington faithfully depicted the costumes and horse tack of Crow tribesmen on the warpath together with the rough log cabins of the Agency buildings. However, the painting, *Crow Indians Firing into the Agency,* has come in for its fair share of criticism. Some of the figures are clumsily drawn and the background is not very well defined. In fairness, oil was not a medium in which Remington excelled at that time and, in any case, the work was intended for conversion into a magazine illustration. It was painted in black and white with clear lines and bold definition. Perhaps it would be fair to describe the picture as an illustration in oils.

The picture appeared in *Harper's* on 5 November 1887, so Remington clearly did not have much time to work on it. The very next day Swordbearer and his Crow warriors were cornered by five companies of U.S. Cavalry. One of the very first shots killed Swordbearer, penetrating his supposedly impervious shirt. The other Crow, realizing they had been following a false prophet, surrendered. The

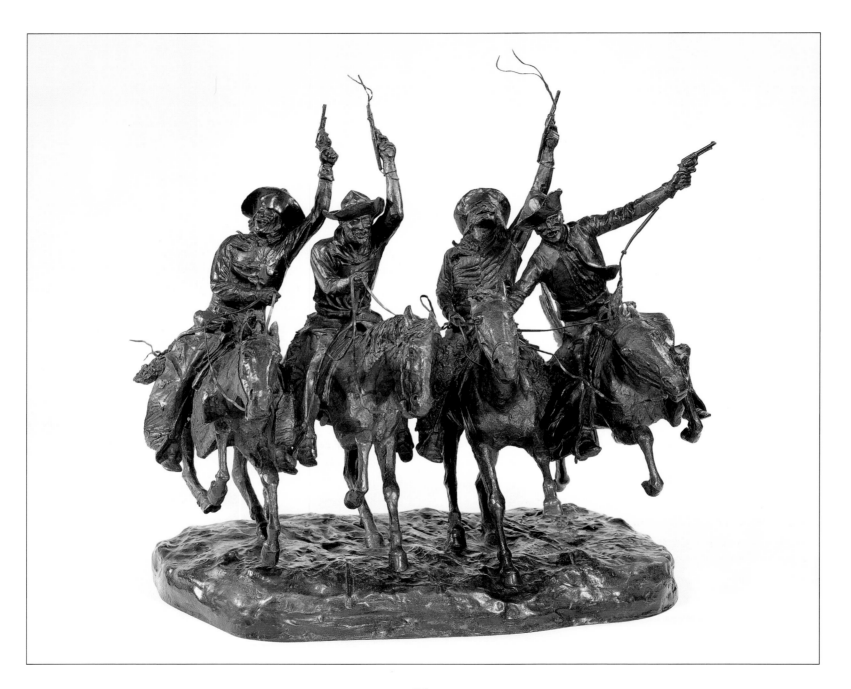

Coming Through the Rye (1902)
Bronze. Height 30⅞ inches (78.4 cm).
Amon Carter Museum, Fort Worth, Texas.

incident was to have uncomfortable parallels with the later Ghost Dance crisis.

Remington persevered with his painting, though his increasing success as an illustrator meant he had little time to spare for unprofitable colour work. In the winter of 1887-88 he produced the watercolour which was to become his first real success in colour. *Arrest of a Blackfeet Murderer* is a relatively simple composition. Against a barren plains background, a fleeing Blackfoot warrior is being overhauled by Agency police. The police level their pistols at the warrior, who raises his arm in surrender.

The painting is an excellent example of Remington's work as an illustrator, and indeed was printed as an engraving by *Harper's* in March 1888. More thought seems to have gone into the composition than quick field sketches would have allowed and there are unmistakable signs of Remington's first faltering steps into the realms of fine art.

In many ways the picture forms a stepping stone between Remington's illustrations and his later paintings. Like *Arrest of a Blackfeet Murderer*, most of his illustrations deal with contemporary events or fictional stories of his own time. However, the picture was deeply symbolic of the changing times in the West, just as his later works often sought to capture a turning point or vanishing culture set in the past.

The murderer is depicted in traditional tribal garb of leggings and loin-cloth, his hair bound in long plaits. He rides a horse without stirrups and with a rope for a bridle and he clearly belongs to the Wild tribes. In front of his horse is a buffalo

skull, symbolizing their rapid extinction. The police are led by a European, but are composed of tribesmen dressed in smart uniforms and with close-cropped hair. The concept of civilized tribesmen replacing wild under the influence of the white man, as opposed to the criminal element which still exists, is clearly drawn.

It was a concept Remington himself later came to reject: but the work and its message were much appreciated by the New York intelligensia of Remington's time. The American Water Color Society accepted the work for their spring exhibition at the Academy of Design in February 1988. *Harper's* not only reproduced an engraving of the work, but heaped praised on both it and its creator. Remington was one of their regular artists and the opportunity to bask in his reflected glory would have done the magazine nothing but good.

Also dating from 1887 is *Return of the Blackfoot War Party*. One of Remington's most accomplished oils to date, the picture shows an incident, memory of which had by then receded into the past. It shows a group of four mounted Blackfoot tribesmen cresting a rise which overlooks their village. As the villagers look on, the leader brandishes a scalp. The warriors have two captives which are being driven forward under the lash. The picture was entered for the National Academy of Design show and provoked much discussion and conjecture.

Early in 1888 Remington received yet another boost to his career, and one which was to cause reverberations far into the future. Theodore Roosevelt, still in the early days of his own career, was commissioned by *The Century Magazine* to write a series of articles on the subject of ranching and hunting in the western

states and territories. Roosevelt insisted that *Century* secure the services of Remington to illustrate the articles. A deal was struck ensuring Remington around $100 for a full-page illustration and pro rata amounts for smaller ones. It was a major coup for Remington and this order of remuneration put him among the higher paid members of his chosen profession as a magazine illustrator.

The celebrity of the author of the articles could do nothing but good for Remington's career. Roosevelt was aged just 30 at the time, making him three years older than Remington. He had been born in New York state, had studied at Harvard and, like Remington, had gone West as a young man to sample the adventure of life on a remote ranch. Hunting was Roosevelt's passion and he appears to have enjoyed nothing better than wielding a rifle up and down the mountains and plains of the American West.

In 1881 Roosevelt had managed to get himself elected to the New York State Assembly. At 21 he was the youngest-ever member of that impressive body, with little patience for the grey heads who ran the state in a cosy arrangement with big business and others with vested interests. Roosevelt spoke out frequently and to great effect against the corrupt manoeuvrings of the New York Republican machine. His exposure of scandals and forthright denunciation of back-room deals earned him wide popularity in the state, but enmity in his own party. Roosevelt turned to writing in order to raise funds for his political career, producing a history, in 1882, of the 1812-14 naval war with Britain. He gained the nickname 'Cyclone' for his tremendous energy and prolific output of speeches and writings.

But in 1884 the blossoming career of the young Roosevelt was dealt a savage blow. His beloved wife died on St Valentine's Day and Roosevelt was distraught. On 10 May he announced he was retiring from the Assembly to hunt buffalo out West: but in 1886 he was back. Roosevelt had begun to see himself as a future mayor of New York and began to concentrate his enormous energies into popular writing and political manoeuvring. This led to a series of articles on the West, collected into a book called *Hunting Trips of a Ranchman*. The articles, and book, were enormously popular and boosted the careers of both writer and illustrator. Roosevelt and Remington remained in touch over the years and their paths crossed to their mutual benefit on several occasions.

Almost as soon as the Roosevelt commission was completed, Remington returned to the West with the Army. Backed by a firm commission from *Century* for illustrations from his trip, Remington set out in June. His brief was to produce illustrations of what were then known as the Wild Tribes. These were tribes whose members were no longer considered hostiles, accepted the government of the white man, but had not yet fully taken to farming. From his earlier travels in the West, Remington knew that such peoples were unlikely to be found close to rail or coach routes which carried Europeans to mining camps and ranches: their villages were in places remote and difficult to reach. Remington eagerly accepted the Army's offer that he should accompany them as a fellow traveller.

His journey from Fort Grant to the Apache tribes around San Carlos brought Remington into contact with the 10th Cavalry, known as the Buffalo Soldiers.

This unit was composed of negro troopers, though most of the officers were white, the reason being that the negroes were deemed to lack the necessary education at this time to be responsible for their own command. The regiment had acquired its nickname from earlier campaigns against the Plains tribes where their patrols through buffalo country and subsistence on buffalo meat gave rise to the name. These tough veterans of past campaigns were now being used as patrols and for intimidation. It was widely believed that the Apache were about to cause future trouble and would leave their reservations at the first opportunity. Regular visits from the feared and respected Buffalo Soldiers would, it was hoped, help keep the tribes under control.

In fact the Army had reason to be wary. In 1886, an Apache named Massai was arrested for various crimes and put on a train bound for prison in Florida. Somewhere in Missouri he broke free of his guards and leapt from the train. He stole a horse, headed west and vanished. Some months later, rumours reached the Army of an Apache warrior living in the Sierra Madres. In spite of patrols of the area and a few exchanges of fire, Massai was still at large when Remington made his trip in 1888. Agency and Army staff alike were nervous that other Apache would follow his lead, rejecting the white man's peace for the freedom of the mountains.

When Remington finally reached the San Carlos Agency, however, all was quiet. Geronimo and the Chiricahua had been forcibly removed and were languishing in Florida. The humid climate was proving unhealthy for a people used to dry mountain air and many Apache were dying of disease. News of their plight was filtering back to the generally less belligerent members of their tribes, giving the Army yet another reason to emphasize their presence.

Remington found the San Carlos Agency to be an edifice of dry stone and adobe perched on a dusty hillside. Much of the compound consisted of a solid, square structure built to withstand attack during the earlier troubles, and now used largely as a storehouse. The heavily buttressed walls were beginning to show signs of age and the adobe blocks sprouted grasses. Nearby, a less forbidding structure with sloping roof and large windows had been built as an office and residence for the Agency staff.

The Apache found there were quiet, almost sullen, and Remington went to work with his pencil. In one of his first sketches sent back to *The Century Magazine*, Remington graphically illustrated the nature of the troubles encountered during his travels. In remote regions such as this, transporting any object was costly and difficult, so he tended to take only the most essential equipment with him, leaving the rest to follow on, as and when possible. At San Carlos, Remington was reduced to using an obliging army officer's back as a board on which to rest his paper when sketching.

The picture on page 36 shows Remington dressed in, what was for him, unusual garb. Although he wears a Colt revolver strapped to his right hip by means of a broad belt, he is otherwise shown as having discarded Western dress. Instead of the cowboy gear he so faithfully drew and often wore, he wears

The Old Stage Coach of the Plains (1901)
Oil on canvas. 40$^1/_4$ x 27$^1/_4$ inches 102 x 69 cm).
Amon Carter Museum, Fort Worth, Texas.

clothing more often associated with British explorers in Africa or India. A sola topi sits on his head, while a thick shirt and trousers cover his body. Instead of chaps, Remington wears leather shin guards strapped around his legs and puttees over his boots. It could well have been this unorthodox garb which caused Remington to feel the discomforts of travel more than usual. His letters home were full of complaints about the heat, the dust and the mosquitoes.

This journey was notable, however, in that Remington brought the one piece of equipment which he did usually manage to carry with him; his camera. Until then, artists working outdoors had to rely on lightning pencil sketches in order to capture the essential details of drawings and paintings which would be later worked up in the studio. The system relied not only on swift pencil strokes, but also on a quick eye for detail. Photographs would seem to be the ideal alternative, but until the 1880s they were generally shunned. Photographic plates were very slow by modern standards, requiring long exposure times. While this was acceptable for landscapes or posed portraits, it was useless for capturing incidents in the open air and action shots were hopelessly blurred. Moreover, the camera and plates were heavy and bulky items to transport. Few artists could be bothered with cameras when a pencil and pad were just as effective and much more practical to carry around.

In taking a camera on his summer trip of 1888, Remington was being decidedly modern, even *avant garde* in his approach. Certainly the contraption would have been a great curiosity in the remote regions he visited. But even as

Remington was grappling with his bulky equipment, manufacturers back East were working to make his task easier. In November, John Carbutt of Philadelphia announced he was launching celluloid photographic film onto the market. Celluloid was considerably lighter and less fragile than glass plates, making photography an altogether less tricky business for travellers. The real breakthrough, however, came in 1889 when the Kodak camera was launched by Eastman's. With a flexible roll of celluloid film instead of unwieldy plates, the camera was much smaller and far more easily manipulated than earlier models. Thereafter, Remington was rarely without his Kodak as well as his sketch book.

Writing in 1898, Remington spoke of his use of the camera: *'Details there must be; they are the small things that make the big things ... the best reason why I use them so little is that I can beat a Kodak – that is get more action and better action because Kodaks have no brains, no discrimination. If Kodak would make an artist's reputation for action they are so cheap that the world would have many such as myself so distinguished, but that is not so. The artist must know more than the Kodak.'* By this time, he had had several years of experience with cameras and his views were obviously not the same as they were in 1888. However, it is probably true that throughout his career he used a camera to record small, easy-to-forget details, but relied on his innate skill to produce the real thing, a work of art.

Having sketched as much as he could during his time with the 10th Cavalry at San Carlos, Remington visited other wild tribes. His first target were the Navajo

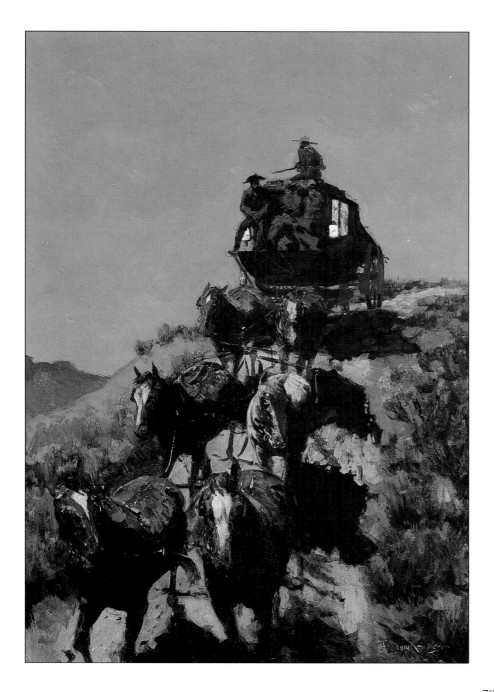

of New Mexico. The origins of the Navajo are somewhat obscure, but they were closely related to their neighbours the Apache. Both peoples had drifted down from the north in the 15th century. The Pueblo tribes already present were suffering hardships, perhaps caused by drought, and offered little resistance to the newcomers. By the mid-19th century, the Navajo were firmly established as farmers in the valleys and around the water-holes of the southwest.

The Navajo's experience of Spanish explorers from the south resulted in an uneasy co-existence with the Europeans. They traded with the Mexicans, and occasionally fought them, but remained otherwise aloof. The advent of the new Americans changed all this. At first they simply fitted into the established trading and warring factions as not especially powerful players. By 1826, Taos, then still in northern Mexico, was well established as a centre for the fur trade where Navajo and mountain men came to trade with merchants from the Eastern states. When the fur trade collapsed a few years later the area declined as far as the Americans were concerned, becoming useful only as a route for wagons between the Mississippi and mining camps. One of the unemployed fur traders, Kit Carson, set up a band of scouts to guide and guard the wagons.

In 1860, following a series of raids and skirmishes, the United States Government decided the Navajo needed taming. Kit Carson was hired to guide the troops. In 1864 he led them to the Canyon de Chelly, one of the most fertile valleys in Navajo territory. Here a bloody battle was fought which concluded with the utter defeat of the Navajo. The tribe was rounded up and sent into exile to the Bosque Redondo Reserve. Before he left, Carson had over 5,000 fruit trees cut down to ensure the canyon could never again harbour hostile tribes. Four years later General Sherman accepted that the Navajo were unlikely to go to war again and allowed them back to the Canyon de Chelly to live under the watchful eye of an agent.

It was these chastened, but still nominally independent tribesmen that Remington encountered in 1888. He was not the first artist to come to the Navajo: in 1874, just ten years after the fighting, a photographer named Tim O'Sullivan had visited the tribe. Already famous for his photographs of the Gettysburg battlefield taken on the final day of fighting, O'Sullivan cemented his reputation with a series of outstanding studies in black-and-white in the south-western desert

The Mountain Man (1903)
Bronze. Height 28⁷/₈ inches (73.4 cm).
Amon Carter Museum, Fort Worth, Texas.

lands. Although Remington also had a camera, he had come chiefly to sketch and to produce drawings fit for engraving and publication in *The Century Magazine*.

One of the main reasons for Remington's commission was the accepted fact that the way of life of the tribes would soon be changed beyond recognition and that, consequently, there was a pressing need to record their history before it was too late. The previous year, President Cleveland had signed the Severalty Act. This act came about through a bizarre alliance between representatives of the frontier settlers who wanted access to reservation land and those humanitarians who believed that the tribesmen should be given legal rights to enable them to integrate into mainstream American society.

Under the Severalty Act, the lands owned communally by tribes would be broken up and handed to individual tribal members. Each family man would receive 160 acres, plus 80 acres for each wife and child in his family. Bachelors were treated as children for the purposes of the Act. The settlers were satisfied with the change as the total land to be apportioned under this system was far less than that held communally. The remainder was to be opened up to European settlers. Less scrupulous land-hungry Europeans resorted to rather more dishonest actions. Unaccustomed to American laws on land ownership, many tribesmen found themselves swindled out of their property, or forced to hand over the land as security for loans and cash which, again, they did not fully comprehend. The Act applied to those tribes which had self-government, principally in the Indian Territory, not to those living under agents or Army control.

When Remington reached the lands of the Comanche in Indian Territory, the situation was chaotic. The authority of the tribal councils, still the nominal government of the area, was breaking down. Thousands of American citizens had moved in. Some had legally acquired land, but others had tricked the rightful Indian owners off the land. The dispossessed, not understanding the white man's law, bitterly resented the loss of their livelihood and took to violence. Elsewhere, gangs of outlaws had secured property and were using it as a base from which to launch raids on surrounding European areas. Local sheriffs and marshals from outside the Indian Territory were officially forbidden to cross the border, but many persisted in leading in posses to enforce some kind of order.

Remington did not stay long. He made his sketches, then headed north to visit the Kiowa and Cheyenne. He found these tribes as quiet as the Apache at San Carlos had been: there was none of the mayhem and growing chaos of the Indian Territory. However, tension was slowly mounting among the once-proud tribes. It was only a matter of months before the Paiute medicine man, Wovoka, would begin the Ghost Dance. But Remington was blissfully ignorant of coming events. He concentrated on his sketching, collected an array of tribal artifacts as studio props and returned to New York. He returned home to his wife in August 1888.

In 1889 Remington's career as an illustrator took a new turn. The technical process by which drawings could be reproduced was changing yet again. The practice of giving illustrations to engravers to transfer them onto wooden blocks for printing was being challenged by photographic etching. The key to the new

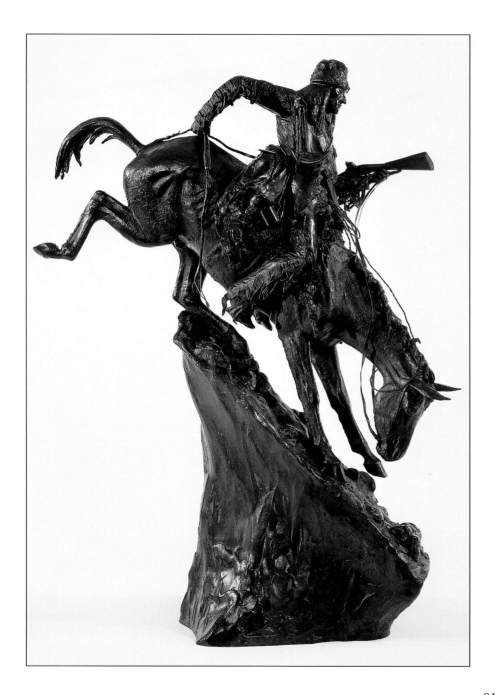

process was the development of chemicals which could work upon metal in novel ways. A sheet of engraving metal was first coated with a photographic emulsion and an image of the drawing shone on to it by means of a bright light. The image was then fixed, the emulsion remaining where black areas appeared on the picture, the rest of the emulsion being washed away. The plate was then bathed in a second chemical which ate away at the exposed metal, but left the part protected by the emulsion. The emulsion was then stripped away. The result was a printing plate, the raised areas corresponding precisely with the artist's pen marks. No longer was the artist at the mercy of a clumsy engraver or a worn wooden block.

Remington, like most illustrators, was relieved and excited. He had long railed against the failure of the old process to do justice to his illustrations and had often chided his publishers on their choice of engravers. He saw the day fast approaching when reproductions of his work would be appreciated by the public in a form closer to their original concept. It was possible to reproduce much finer detailing with photographic etching on metal but the process was, however, extremely expensive. Publishers were unwilling to use it unless it was for high-prestige book or magazine covers or full-page illustrations. It would be some years before the technique was applied to every page.

In spite of these important changes in the world of commercial art and Remington's unprecedented success in the field, his sights were already set elsewhere.

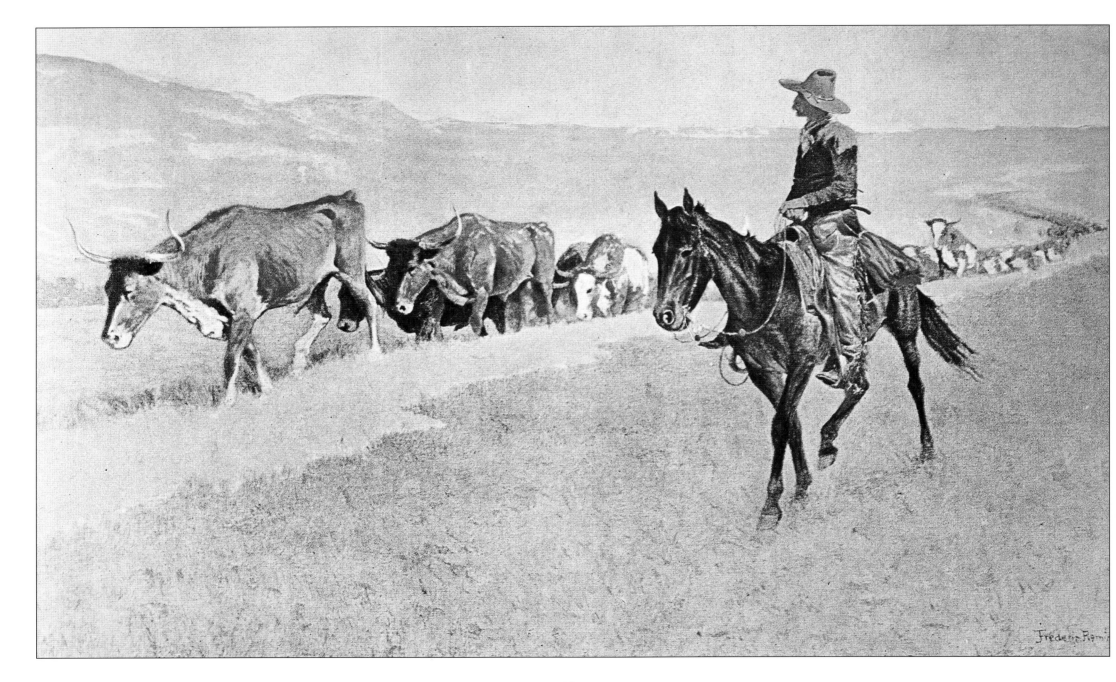

Chapter Five
Into Oils

Remington's ambition to be a painter burned as brightly as ever despite his growing success as an illustrator. Increasingly he was seeing the world of fine art as the natural home of his talents and of the Western themes he loved.

In the spring of 1889 he sent five works to Paris for consideration for the Paris Universal Exposition. Four of these were in black-and-white and received little interest from the French; but his oil *A Lull in the Fight* provoked a quite different reaction. At that time, the French academic world was still dominated by the hidebound attitudes of the past, best exemplified by the Academy's rejection of the work of the Impressionists as mere daubs. It is perhaps for this reason that American artists were divided into two groups, the first being those who worked in Europe (which to the French largely meant France) and accepted European styles as approved by the Academy. The second group were termed 'natives', who preferred to work and remain in America. There was little doubt among the art establishment in Paris which group was considered superior.

The public, however, had other ideas and took to Remington's *A Lull in the Fight* with enthusiasm. The subject matter helped, for it depicted a scene from 1861 when the Comanche were engaged in a war with a neighbouring tribe. The battle shown was one of the more important encounters of the war and ended in victory for the Comanche. The authenticity of the costumes and landscape, as much as the verve of Remington's rendition, inspired loud public approbation and it was awarded a Silver Medal by the Selection Committee.

While *A Lull in the Fight* was hanging in Paris, Remington was to receive firm recognition of his growing skill with oils in the most tangible form. The industrialist, E.C. Converse, commissioned him to paint a monumental canvas measuring slightly more than 48 x 84 inches (122 x 213 cm). The subject was to be a frontier fight. Remington chose to depict a typical skirmish of the 1860s between European and Apache. Remington knew that such engagements, although short-lived, were bloody in the extreme and featured ambushes and running fights.

The finished painting shows a group of eight Americans and Mexicans fleeing headlong from a group of Apache. They are attempting to reach a small stand of trees where they can find cover and hold off their attackers. He called the work *A Dash for the Timber* (page 63), and it proved to be his first great success in oils in America. Fully aware of the importance of a first large commission to his future career, Remington made great efforts to turn out a masterpiece. He wrote to friends in the West asking them to purchase various items of cowboy clothing and equipment and send them to him so that he could be certain of absolute authenticity. He invited fellow artists to visit him regularly in order to view the painting as it took shape and to offer advice.

The painting was eventually unveiled at the autumn exhibition of the National Academy of Design in New York. It was an immediate success. The press hailed it as marking the emergence of a new force in oil painting and as a major turning point in the career of Remington, already acknowledged to be one of the nation's

finest younger artists.

That same year, Remington was invited to dine at Delmonico's restaurant by Henry Harper. He found himself in the company of writer Thomas Janvier, so clearly the meeting was to be no ordinary one. Delmonico's was the finest eatery in the city. Founded in 1831 by two Swiss brothers, the establishment was the first in New York to offer a menu more extensive than a simple dish of the day. Lunch at such a smart venue was hardly the place for an editor to conduct an editorial briefing, but Henry Harper had a major proposition to put to his two guests. He required them to travel to Mexico, this time for a rather more extended trip than had been possible after the Apache campaign.

Remington and Janvier were to spend over eight weeks in Mexico, most of the time in Mexico City itself. However, Remington was keen to visit army bases to produce a series of pictures of the Mexican military. Having travelled extensively with the U.S. Army, Remington knew its equipment, drill and daily routine intimately. The chance to study a foreign army at first hand could not be passed up. First, however, the permission of the Minster of War was required.

It was 40 years since the war between the United States and Mexico which had led to vast territories being annexed from Mexico. Now relations between the two nations were much more friendly. The government of President Porfirio Diaz had been swept to power by an army coup, confirmed by an election, in 1876. Under Diaz, Mexico was rapidly modernizing her transport and industry. Railroads were built across the nation and factories established to help ease the

chronic economic problems. Among Diaz's most consistent policies was the need for concerted effort to win international recognition for Mexico and himself. Remington and Janvier were the kinds of foreign journalists Diaz welcomed to visit his country and spread favourable reports to the world outside. His government ensured that the two Americans were allowed to explore at will, and even visit military posts.

Remington was free to stay at the various military bases and mix with officers of the units he found there. As well as producing pictures for *Harper's*, Remington also made a number of sketches for his own collection. Some of these were later worked up into oils for sale, or for publication as colour plates in books and magazines. Remington seems to have enjoyed his time in Mexico and to have been enthralled by the very Mexican attitude towards uniform and drill. The infantrymen, for instance, spent most of their time in linen and cotton suits but wore open sandals. For parades, however, they had woollen uniforms and leather boots which were easily as fine as those of any army.

The pair also made the rounds of farming communities and rural villages. Janvier, gripped by the dramatic force of Mexican bull fights, wrote several articles and Remington produced drawings to accompany them. He also produced numerous sketches and drawings of rural life, and a few oils were completed to be used as colour plates in a collected version.

By the spring of 1890 Remington was earning so much money that he could afford to move out of New York City altogether. He bought a large house at New

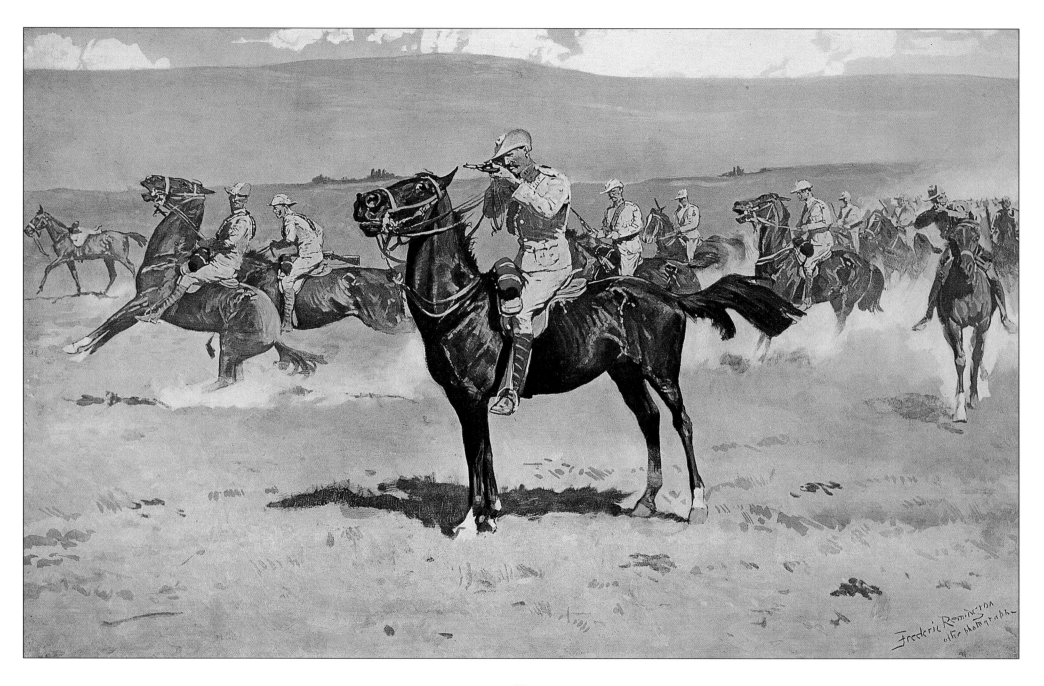

The End of the Day (c. 1904)
Oil on canvas. 26½ x 40 inches (67.3 x 101.6 cm).
Frederic Remington Art Museum, Ogdensburg, New York.

Rochelle (page 15), where he established a studio. It was here that he worked at producing the illustrations which provided the mainstay of his income, and the paintings which were increasingly occupying his time and attention. Yet he still found time to travel to the West in search of new objects to add to his extensive collection of cowboy and tribal clothing and artifacts. These trips were Remington's life-blood. They enabled him to visit new regions and new peoples thus ensuring the continuing authenticity of his work. He was also able to keep pace with the changing face of the West, again necessary to maintain the reputation for attention to detail which was a feature of his growing career.

That summer, he travelled north of the Canadian border to Alberta which was still, at that time, a largely unpopulated land. The territory – it was not yet a province – stretched from the headwaters of the Athabasca river to the confluence of the Bow and Saskatchewan rivers. The Canadian Pacific Railroad had been completed a few years earlier, but a desperate economic slump restricted farmers to cultivation of the areas immediately adjacent to the tracks. The bulk of the land was still dominated by buffalo, cattle ranchers and fur trappers.

When Remington arrived, there was considerable distrust of the Americans on the western prairies. Many people believed that the United States had ambitions to annex the entire region, restricting the Canadians to the settled regions of Quebec, Ottawa and the Maritime Provinces. Some thought the longer term aim of the United States was to take over Canada entirely. The issue dominated the Canadian election of 1891, resulting in the return to power of a

Conservative Party totally dedicated to preserving Canadian borders and independence.

Part of Canada's response to the perceived threat of American expansion was to enforce law and order in the vast unsettled lands. Not only would this halt the bloodshed which had scarred the southern plains, it would also bring an end to unrestricted settlement of American citizens of the type leading to the loss of Texas by Mexico. The body of men charged with keeping order was the North-West Mounted Police.

Remington came across the Mounties during his visit and was much impressed by them. Their summer uniform of red coat, grey trousers and blue hat was both striking and impressive. They were locally known as the dandies of the plains, and Remington produced drawings of this tough body of men for *Harper's*. He was equally taken by their winter gear, designed to combat the bitter cold of the Canadian high prairies. It was based on the winter regulation uniform of the British Army light cavalry, which itself derived from the cavalry of Hungary. The Mounties wore tall fur hats, topped by cloth pouches. The red jacket was replaced with a long fur coat, often made of buffalo hide, double-breasted and fastened with straps and braiding. Even the horse tack was altered, with wood replacing many metal fittings.

Remington produced a painting in oils of a squad of Mounties caught in a blizzard, resplendent in their flamboyant winter gear. For Remington, fascinated as he was by all matters military, these uniforms were distinctly reminiscent of

European army uniforms.

Remington returned to New York after his Canadian trip to continue working, but in October he was sent West by *Harper's* as the Ghost Dance crisis engulfed the plains. The Ghost Dance had begun in the early months of 1889 when a Paiute medicine man named Wovoka fell into a deep three-day trance. This trance produced a vision of the Great Spirit who promised him that the spirits of dead ancestors would move among the tribes and the buffalo would return, provided the warriors and their women performed a new dance. It was a simple dance, consisting of holding hands and moving first to the left, then to the right. It was dubbed the Ghost Dance and spread rapidly among the tribes.

As time passed the new dance took on a religious aspect. The Sioux were particularly taken with it and elaborated on Wovoka's vision with others of their own. By the winter of 1889, the Great Spirit had promised that the white man would leave the plains and that special Ghost Shirts would protect wearers from all harm, including bullets. The Army and Agency staff began to get nervous. It was only two years since Swordbearer had made similar promises concerning his magical shirt before instigating a small rising of Crow tribesmen. Some feared that a major insurrection by the Sioux was gathering force.

In September 1890 came the first bloodshed, though it later emerged that the Ghost Dance was not the main cause. In Montana two Cheyenne, Young Mule and Head Chief, bored with constantly having to eat Agency meat, went out hunting. They killed a cow. A passing cowboy rode up to object and made the mistake of referring to the men as dogs. He was shot dead. When the army arrived to arrest the culprits, the Cheyenne reservation was thrown into turmoil. Tribal elders attempted to discuss the situation with army officers, while younger men fingered their guns. Eventually, Young Mule and Head Chief decided not to involve their fellow tribesmen and rode away. When at a decent distance from the main camp, the two men donned their war bonnets and charged at the pursuing soldiers. Both were killed in seconds.

Made anxious by this incident and by the increasing fervour of the Sioux Ghost Dancing, the head of the Pine Ridge Agency put in a request for troops to back up his tribal police. Henry Harper also heard the news and dispatched Remington to Pine Ridge to cover the developing story. After a few weeks, when nothing much was happening, Remington returned to New York.

Remington had been shocked by what he had seen and the tensions caused by the Ghost Dance. Until the advent of this phenomenon there had been genuine hope that the tribes could be taught to farm and to assimilate into mainstream American society. There had been examples of success. In Florida a group of Kiowa and Comanche, in prison for various crimes, were taught carpentry and blacksmithing which enabled them to get jobs in local towns. But now it seemed that the plan to integrate the tribes as a whole was doomed to failure.

Some thought the tribes were bound for extinction: death rates from smallpox and other diseases were appallingly high, while the birth rate remained low. The Tasmanian Aborigines had become extinct a few years earlier and the

The Moose Country (1909)
Oil on board. 18⅞ x 15 inches (47.9 x 38.1 cm).
Frederic Remington Art Museum, Ogdensburg, New York.

An Old-Time Plains Fight (c. 1904)
Oil on canvas. 27 x 40 inches (68.6 x 101.6 cm).
Frederic Remington Art Museum, Ogdensburg, New York.

same was already happening to some American tribes. Remington had ideas of his own and wrote an essay on what he termed the Indian Problem.

Remington rightly surmised that the reason the Sioux were so quick to embrace the Ghost Dance was because they were demoralized, feeling themselves to be men without purpose confined as they were to the reservations. With no buffalo hunts or intertribal horse raids to enliven their lives, it was hardly surprising that they grasped at the chance of obtaining some semblance of dignity and hope. Remington argued that this longing for a sense of self-worth to be restored to them should be utilized by enrolling the tribesmen in the Army. The British in India were already forming Sikhs and Gurkhas into special regiments to serve alongside regular British units where only a generation earlier the British had fought savage wars against these same people. Could not the United States do the same? argued Remington. The tribesmen were widely regarded as superb light cavalry and as scouts could prove a useful addition to the U.S. Army. Remington himself wrote that '... they could take a Cossack and milk his mare on the run'.

But Remington had chosen the wrong moment to leave Pine Ridge and write his piece.

On 19 November a new force of cavalry arrived at Pine Ridge, commanded by General John Brooke, an officer mistrusted by the Sioux. Hundreds of Ghost Dancing Sioux and their families left the reservation, heading for their relatives in other reservations. Two major bands, led by Kicking Bear and Big Foot, fled to the Dakota Badlands. Reporters sent *Harper's* stories of a major uprising, though

no fighting had taken place. Remington was ordered back to Pine Ridge.

Events were moving fast. On 14 December, General Miles in Chicago ordered the agents to take the precautionary step of putting all Sioux chiefs still on reservations into locked compounds to prevent them from leading their people to join Kicking Bear or Big Foot, now considered possible hostiles. Next morning the arrests began. When the Agency police, all of them Sioux, tried to arrest Chief Sitting Bull they found themselves surrounded by an angry crowd. A scuffle broke out and Sitting Bull, along with 11 others, was killed. As news of Sitting Bull's death spread, hundreds more Sioux left their reservations.

Remington arrived back at Pine Ridge to find the Agency a camp in turmoil. Hundreds of Sioux and Cheyenne were present in an attempt to affirm their loyalty and friendship. Dozens of lodges were lying in ruins, destroyed by the Sioux who had left to follow Kicking Bear and Big Foot while at the same time soldiers were being sent in to restore order. The famous 7th Cavalry was present under Colonel James Forsyth, together with various infantry regiments and detachments of troops which had been rushed to the scene from scattered outposts.

After Remington's arrival, news reached Pine Ridge of a skirmish fought between Kicking Bear's Sioux and a small force of Cheyenne acting as scouts for the Army. It looked as if a major war was about to begin. Then, on 28 December, the 7th Cavalry found Big Foot and his 350 Sioux at Wounded Knee Creek, north of Pine Ridge. The Sioux maintained they were coming to surrender. It was late in

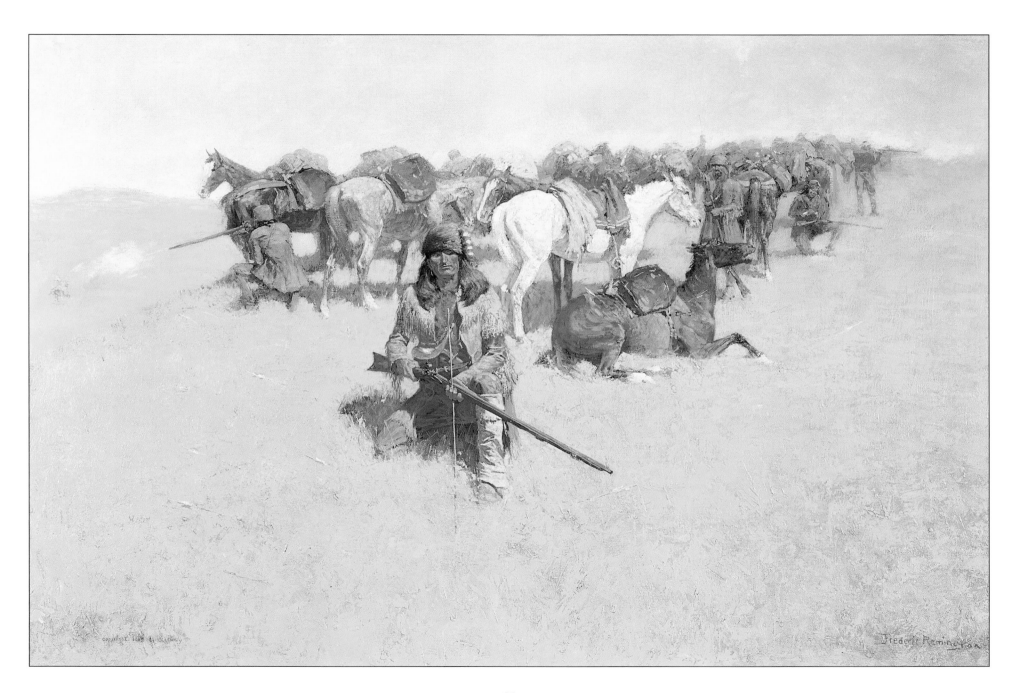

The Sergeant (1904)
Bronze. Height 10^{1}/$_{8}$ inches (60.6 cm).
Amon Carter Museum, Fort Worth, Texas.

the day and both sides settled down to an uneasy night.

Just after dawn Forsyth ordered the Sioux to leave their tents and surrender their arms. The Sioux appeared but did not hand over their weapons and Forsyth ordered some of his men to disarm them. As the soldiers moved in, tension mounted alarmingly. The Sioux believed they might be punished by banishment to Florida where they would be abandoned to die of fever. Then a medicine man named Yellow Bird began the Ghost Dance. Others joined in. When a shot rang out, everyone reached for their weapons. Within a few seconds dozens of soldiers and Sioux were killed. When the Sioux fled, Forsyth opened up with his Hotchkiss guns. In all some 30 soldiers and 150 Sioux died that day, or later of their wounds.

Whatever Remington's actual movements were on that day, it is likely that he spoke to many witnesses of the incident including Colonel Forsyth himself. His portrayal of the fight shows the early stages of bloodshed when the Sioux and cavalry troopers are engaged in close-range fighting. It was this view of the battle which dominated the eyewitness accounts and the early versions of events at Wounded Knee. It was only later that the following Hotchkiss gunnery come to dominate accounts, presenting the event as a massacre.

When the news of Wounded Knee spread, the remaining Sioux fled to the wilds fearing the worst. General Miles hurried to South Dakota, calling on Buffalo Bill as a scout. One force of enraged Sioux pounced on the 7th Cavalry and drove them from Wounded Knee Creek. Another force struck the 9th Cavalry,

sent in as reinforcements. Ambushes and skirmishes continued until the end of January, when the Sioux abruptly surrendered.

Far away on the Paiute reservation the news eventually reached Wovoka, the medicine man who had initiated the Ghost Dance almost two years earlier. He was appalled and went into immediate mourning. He entreated his followers, claiming that the Sioux had distorted his message and imploring them to drop the whole idea.

Remington's idea of recruiting the tribes as light cavalry was just one of several being discussed at the time. Sadly, perhaps, it was never taken up. The tribes remained on their reservations, individuals forsaking the tribe from time to time for employment in towns or on ranches and farms. Strife continued to a certain extent, though never again on a tribal scale. As late as 1911 a gang of Shoshone embarked on a cattle raid in Nevada. These were the last days of tribal warfare.

Remington, his theories of tribal life rejected, returned to his art. As well as continuing his illustrations for *Harper's* and other magazines, he continued to produce oils. *A Cavalryman's Breakfast on the Plains* is an early example of the military works which would become standard fare for Remington. In the picture, individual groups of six men squat or stand around their fires while their ham fries and their coffee boils. There are no signs of tension, so it is unlikely that they are on active service during the Ghost Dance crisis. More likely it is the summer of 1889 or 1890 when the troops were on regular patrol, displaying the

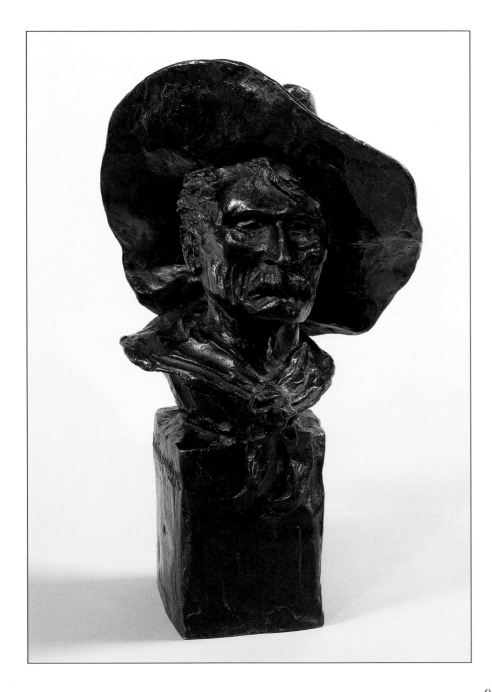

force of their strength to the tribes.

Also from this period were a series of water-colours depicting individual soldiers which Remington had met during his travels in 1890. Some of these were used as illustrations when his article on the feasibility of employing tribesmen as light cavalry was published in *Harper's*: others were used elsewhere or sold privately.

The following year Remington once again entered a work in the spring show of the National Academy of Design. This work, *Arrival of a Courier*, was one of his first efforts at recording past history. It shows an incident from the campaigns of General Crook, one of the few U.S. generals to enjoy success in battle against the Apache and at the same time earn their respect. During his time in Arizona during the Apache wars, Remington would have met many men who fought with Crook and would have collected numerous artifacts of Apache and south-western clothing and equipment.

The picture was a greater success than Remington had envisaged. In June, the National Academy of Design elected him an associate member. Remington could now place the coveted letters A.N.A. (Associate National Academician) after his name. He had arrived as an artist, respected and recognized by the established art world. That autumn he completed a huge canvas of cavalry forming into line at a trot, which sold for $5,000.

In January 1892, Remington received a commission to provide illustrations for a prestigious reprint of Francis Parkman's classic history *California and the Oregon Trail*. Although he was in the last few months of his long life, Parkman took an active interest in the project. Knowing that Remington prided himself on his authenticity, he suggested that the artist might look at the works of the German artist, Karl Bodmer, who had travelled West in 1833. His works form an important record of the Plains tribes before disease decimated their numbers and imported guns and changes in dress altered their culture. For the first time in his career, Remington opted for an imaginative treatment rather than strict accuracy. He went on to produce a series of pictures of the days of the Oregon Trail as the Americans of the 1890s imagined they might have been. Presumably he thought he knew his target market better than the ageing Parkman.

However, Henry Harper was rather more interested in the kind of impact

93

PAGE 96
The Howl of the Weather (1905-1906)
Oil on canvas. 27 x 40 inches (68.6 x 101.6 cm).
Frederic Remington Art Museum, Ogdensburg, New York.

The Rattlesnake (1905)
Bronze. Height 23⁷⁄₈ inches (60.6 cm).
Amon Carter Museum, Fort Worth, Texas.

Bodmer's work would have on Remington than the artist was himself. Harper decided that his young protégé would gain much from increased exposure to foreign artists. What was needed, thought Harper, was a trip to Europe. Remington was unconvinced. He was forthright in his view that the American landscape was the best suited to his brush and that frontier characters were by far his speciality. Harper persisted, however, tempting Remington with the prospect of sketching and painting the armies of Europe. Eventually, it was the promise of a canoe trip down the Volga and a meeting with genuine Cossacks which won the argument.

Remington left for Europe in May 1892, arriving in London after an uneventful voyage. In London he had a pre-arranged meeting with his old friend from his days at Yale, Poultney Bigelow. The pair crossed the English Channel to France, travelling rapidly on through Germany towards St. Petersburg. They had planned to travel overland to just north of Moscow where they could pick up the mighty Volga to cruise downstream towards the Black Sea. Unfortunately, the Russian government had other ideas.

For over a century, the United States had had a profitable trading relationship with China. In 1867 the Americans annexed Midway Island and 20 years later established a naval base in Hawaii to protect the sea routes from California. But China was weak and had a corrupt government. In 1858 and 1860 the Russians took advantage of this to seize the Amun and Maritime Provinces. Now Russia was eyeing the wealthy province of Manchuria and looking for an excuse to invade. The United States, concerned that its profitable trade might be disrupted, opposed Russian plans.

Given the tense diplomatic situation the last thing the Russian government wanted was a famous American artist visiting her military bases. Remington's lifelong interest in the military, and in particular cavalry units, was viewed with deep distrust. He could just as well be a spy sent to assess Russian military strength. The Tsar ordered Remington and Bigelow to leave Russia at once.

The American pair were not, however, going to leave without a struggle. Having reached Kaunas, in Lithuania, they left the rail train in which they were travelling and embarked on a river steamer. When their foreign appearance began to attract attention, they transferred to the roads, hitching lifts on farm carts. Eventually, however, the Tsarist secret police caught up with Remington. He was unceremoniously bundled out of Russia into Germany, and was lucky to be allowed to keep his sketches. Remington's experience of Russia was not a happy one. In later life he often mentioned the oppressive nature of the Tsarist secret police and their all-pervading intelligence service. Such concepts were quite alien to a free-born American citizen.

In Germany, Remington and Bigelow spent time in fruitless correspondence with Russian officials. They visited the Kaiser's horse farm and enthusiastically sketched the varied landscapes and peoples of the German Empire. Finally, despairing of ever being allowed into Russia, they travelled south, across the Mediterranean to North Africa. Here the desert landscapes and harsh light

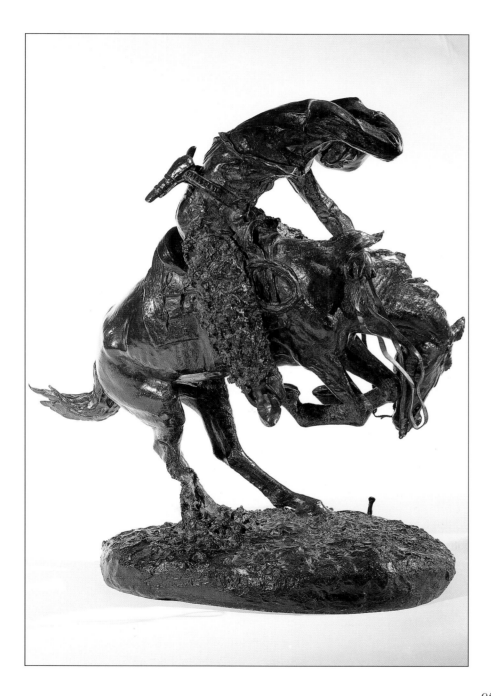

reminded Remington of Arizona and he sketched some more.

The pair finally fulfilled Henry Harper's original intention by visiting Paris to view the great museums and galleries, filled to the brim with centuries of Europe's finest art. Encouraged by Bigelow, Remington began to study the styles and techniques of the masters. He admitted later that he learned something from these visits, but not much. He still remained unimpressed with European art when he returned to America in the autumn.

In January 1893, Remington considered himself accomplished enough as an artist to break into the mainstream. He opened a one-man-show at the American Art Association. The show included sketches, studies for illustrations and his beloved oils. They were to be shown for a week before being sold by auction. The drawings and sketches sold well, realizing good prices. But the paintings failed to catch the attention of buyers. He sold *A Lull in the Fight*, which had so impressed the French four years earlier, but others were withdrawn when they failed to make the reserve price. A similar result followed a second exhibition in 1895.

Remington was bitterly disappointed. He considered his oil paintings to be his finest work and despaired of ever being anything other than a professional illustrator. Then he made a new discovery, one which was to rejuvenate his career. He discovered bronze.

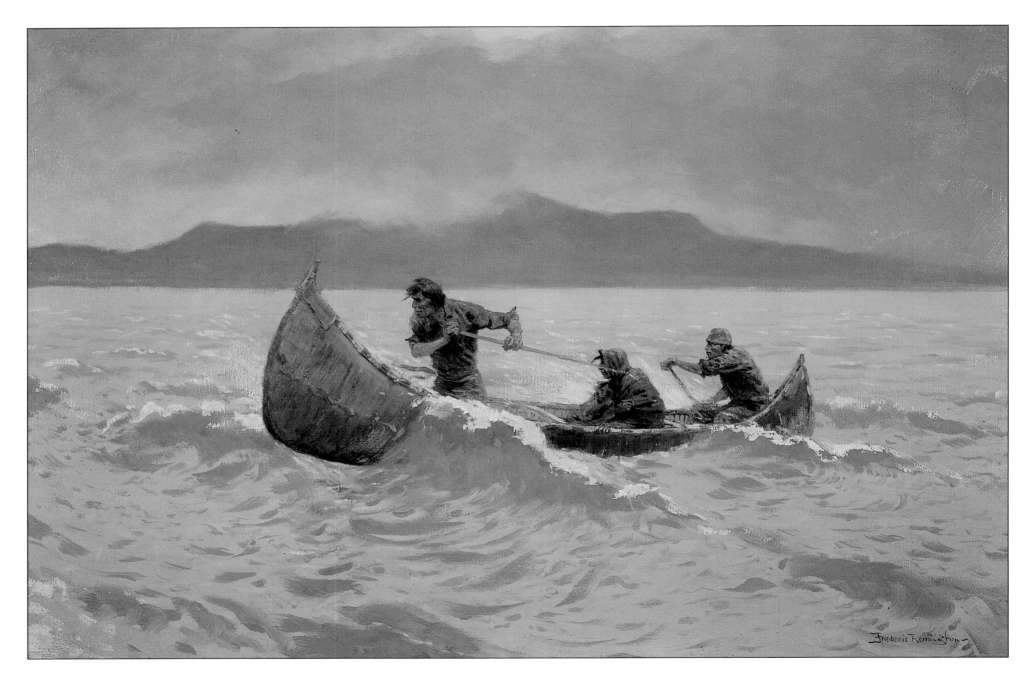

Chapter Six
Coming of Age

Remington's discovery of bronze as a medium for sculpture came about almost by accident, but having found it, he took to it with alacrity. In the spring of 1895, Frederic Ruckstull was given the task of crafting a statue of General John Frederick Hartranft for the state government of Pennsylvania. Like Remington, Ruckstull was living in New Rochelle and he set to work on his sculpture at the home of Augustus Thomas, a writer also living in New Rochelle. Remington was in the habit of dropping in on Thomas, and it was there that he was introduced to Ruckstull.

As time passed, Remington began to develop an interest in Ruckstull's work. He had little time for the severely classical style of Ruckstull's sculpture, but was fascinated by its three-dimensional quality. After a few weeks of questioning and pestering by Remington, Ruckstull presented the painter with a tub of modelling clay and some basic tools and, under his guidance, Remington went to work.

As his subject, he chose a cowboy on a bucking bronco. This was a natural choice for Remington and had not yet been attempted in bronze by an American artist. The subject allows for some dramatic movement as the bronco twists, turns, dives, or arches its back, while the rider, perched on is back, can be similarly displayed in almost any exciting position.

Remington began work on his sculpture in the late spring and spent long hours on the initial clay model. He was delighted with his new discovery: he wrote to friends that he had finally dicovered the way to immortality. While his watercolours would fade, his magazine illustrations be discarded and his oils eventually crumble to dust, the bronze would endure forever. The physical sensation of modelling in three dimensions appealed to him greatly – he was in his element.

The work was finally finished in October. Remington took his sculpture to the Henry-Bonnard foundry for casting. At first, the casting was restricted to about a dozen copies. Producing bronzes was an expensive business and Remington had already spent much time on the work. He had no wish to expend a great deal of money as well. He was well aware that a work of this type needed to sell around 20 copies to be commercially viable and desperately hoped that they would sell quickly so that he could get to work on a second sculpture.

The *Bronco Buster* was announced to the world in *Harper's* on 19 October 1895. With its customary support of Remington, *Harper's* produced a glowing review of his new venture. The art critic Arthur Hoeber was employed to write the piece, and he did his work well: *'Breaking away from the narrow limits and restraints of pen and ink on flat surface, Remington has stampeded, as it were, to the greater possibilities of plastic form in clay, and in a single experiment has demonstrated his ability adequately to convey his ideas in a new and more effective medium of expression.'* No artist could ask for better. Other critics were less kind. They argued that the work did not seem very three-dimensional and was little more than an illustration in bronze.

With the backing of *Harper's*, the work drew immediate attention. The public was as much impressed by the subject as by the spirited rendering of a leaping horse and its rider. Orders came flooding in for the piece which eventually sold over 300 copies. Remington was overjoyed and embarked on his next bronze.

The Wounded Bunkie (page 67) appeared in 1896 and indicates that Remington was advancing, both in technical expertise and artistic daring. This second piece was rather smaller than *The Bronco Buster* (a larger version was

produced in 1909) though it included two horses and riders. The subject, that of a soldier tending to his wounded bunkmate under fire, was popular with the American public, having appeared in several magazine illustrations: so Remington was on safe ground. However, by perching each of the galloping horses on just one leg he was taking chances both with the casting and with the inherent stability of the piece. That he managed to achieve both in a coherent artistic composition shows how rapidly he was getting to grips with this new medium. The piece was, once gain, cast at Henry-Bonnard and sold well.

Much as Remington loved making sculptures, he knew he must continue as an illustrator in order to earn a living and keep himself to the fore of the public eye. He progressed to pen-and-ink wash as the new techniques of printing made hard lines unnecessary. He did not abandon oil painting entirely, though it was gradually taking a new turn.

With hindsight, one might consider the most important painting of this period to be *The Puncher* (1895). This simple composition shows a cowboy of the southern plains astride his horse (which has the typical long stirrups) glancing sideways at the viewer. Remington completed the picture as a gift for fellow artist Howard Pyle who had earlier sent Remington one of his own pictures. Remington made a conscious effort to capture the very essence of the archetypal cowboy. He managed to convey, not only the outward trappings of the Westerner, but also his rugged individuality and dogged determination to see a job through to the bitter end.

In his later works, Remington increasingly made use of such 'typical characters'. He increasingly abandoned the task of representing real events of the past and instead began to produce imagined scenes. Remington would take certain stock characters – gamblers, cowboys, cavalry troopers, fur trappers, tribesmen hunting buffalo, tribesmen on the war path – and place them in different situations against a Western landscape. The trend was to become increasingly noticeable as the years passed.

In 1896 Remington was contacted by the newspaper magnate William Randolph Hearst. He was asked to go to Cuba to provide pictures of the growing crisis between the Spanish colonial authorities and seekers of home rule. Remington agreed and set out early in 1897, accompanied by the writer Richard Davis. They were commissioned to produce a series of articles for Hearst's magazines, which would later be collected together into book form.

Hearst had already come out strongly in favour of the rebels, in June 1895, when his papers printed a series of pieces calling on America to go to the aid of colonists fighting their own war of independence as the United States itself had a century earlier. President Cleveland, however, considered that any involvement would be undoubtedly expensive and might disrupt trade with Spain and other European powers. He did, however, offer to act as arbitrator between Spain and the rebels, an offer rudely rejected by the Spanish.

Remington's trip was arranged through the regular travel companies which set him and Davis ashore at Havana, where they were at once taken in hand by

the colonial authorities. The Spanish attempted to show the visiting American journalists a confident and happy picture of Cuba. According to their hosts, the rebels were a minority interest made up principally of brigands and crooks intent on plundering the law-abiding and looting American businesses. But, just as in Russia, Remington managed to slip away from the officials and take a look for himself. He found that the Spanish troops, in trying to put down the rebellion, were guilty of the most dreadful atrocities towards peasants and traders showing the slightest sympathy with the concept of home rule. In rural areas, entire villages were placed under armed guard and brutally treated.

Despite such atrocities, there was no actual fighting in any of the areas visited by Remington. He sent a telegram back to Hearst explaining the situation which concluded: 'Everything quiet. No trouble here. There will be no war. I wish to return. Remington.' Hearst sent back one of the most famous telegrams in history: 'Please remain. You furnish the pictures and I will furnish the war. Hearst.' Hearst would eventually keep his promise, but not for some months.

Remington and Davis returned to New York to file their articles and pictures. They painted a gruesome picture and further fuelled Hearst's indignation at the official inaction. Hearst's newspapers repeated the stories of atrocities and whipped up public opposition to Spanish control of Cuba. In March the new President, McKinley, declared his opposition to America's taking up of arms. But he carefully worded his statement so that Spain was left in no doubt that war was an option, albeit a remote one.

Over the course of the summer, events in Cuba progressed steadily towards crisis, anxiously watched by Remington. If war was to come, Remington wanted to be with the Army when it happened. Having witnessed the last of the Western wars against the tribes, he was keen to see the U.S. Army in action against a more modern enemy. In May, Congress voted $50,000 to provide humanitarian relief for Americans in Cuba. In November, Spain recalled her most brutal commanders and installed officers with more moderate attitudes. There was even a promise of limited self-government. But the rebels had suffered too much to be satisfied with anything other than complete freedom.

In January 1898 President McKinley sent the U.S. Navy's most modern battleship, U.S.S. *Maine,* to Havana. He declared the visit was to show friendship to Spain, but many others interpreted it as a none-too-subtle demonstration of American power in the area. The Spanish received the ship and its men courteously enough, but clearly resented having a foreign warship in their port. Whatever the motives of the visit, it had cataclysmic effects.

Just after sunset on 15 February, a massive explosion tore through the *Maine*. Over 250 men were killed and the ship went straight to the bottom of Havana harbour. Almost at once rumours began to circulate that a large mine had been exploded by the Spanish authorities. Though there was no evidence of this, the incident was reported as fact by the Hearst press and there was great public outcry demanding war. Hearst was about to keep his promise.

Remington received the news via a telephone call from Augustus Thomas. He

The Last March (1906)
Oil on canvas. 22 x 30 inches (55.9 x 76.2 cm).
Frederic Remington Art Museum, Ogdensburg, New York.

slammed the phone down, picked it up again and called *Harper's*. He demanded to be sent to Cuba as part of the magazine's reporting team. *Harper's* agreed. After some preliminary diplomatic manoeuvring, war was declared on 25 April. Six days later a U.S. fleet under Admiral George Dewey sailed into Manila Harbour in the Philippines and sank the Spanish Pacific Fleet. May 12 saw a second U.S. force bombard San Juan, Cuba, and the U.S. Army under General Shafter was quickly ashore.

Arriving in Cuba, Remington found two units with which he already had close ties. The 10th Cavalry, the negro 'Buffalo Soldiers' whom he had encountered in the Apache Wars and during the Ghost Dance crisis, formed part of the invading force. Also present was Theodore Roosevelt, who had raised a regiment of frontiersmen known as the Rough Riders.

By 1 July, General Shafter had his main army in position around the city of Santiago. A series of formidable blockhouses and entrenchments on the San Juan Heights blocked any further advance, but Shafter knew he could not hesitate. Already some of his men were falling sick with malaria caused by the mosquitoes which infested the low-lying swamps where they were encamped. He was forced to take the heights and the city or watch his army dwindle away in disease. He gave the order to attack.

Remington took up a position on the left flank of the advance, close to the 10th Cavalry and facing San Juan Hill itself. Roosevelt and his Rough Riders (page 55) were to the right, facing Kettle Hill. The artist settled himself into a

trench commanding a view of the Spanish positions on the heights above and spread his sketching materials around him. He was determined not to miss any incident which might be useful for a sketch or illustration, although he was not feeling well that day.

The attack began just after dawn as the infantry advanced to take preliminary positions and clear away barbed wire fencing. At noon, the 10th Cavalry advanced in front of Remington and the Rough Riders surged up Kettle Hill to his right. Ever the showman, Roosevelt was armed with a pistol salvaged from the wreck of the *Maine* with which to exact revenge on the Spanish. The advance soon deteriorated into confusion as units and their commanders became separated in the rough terrain.

On the right flank Roosevelt managed to save the day. Faced with the refusal of the captain in command of his support to move forward without direct orders from his own colonel, Roosevelt loudly declared that he was the senior officer present and urged his horse forward. Roosevelt led his Rough Riders at full gallop, and anyone else who chose to follow, up Kettle Hill. Halted by barbed wire entanglements, Roosevelt leapt off his horse and led his men on foot to the summit of the hill. After a brief hand-to-hand conflict, watched through the smoke by Remington far below, Roosevelt took his objective.

To Remington's front, the advance was pinned down by heavy fire from a blockhouse. Roosevelt ordered his men to pour fire on to the fortification while he led a small force of Rough Riders in a flanking charge. For the second time in a

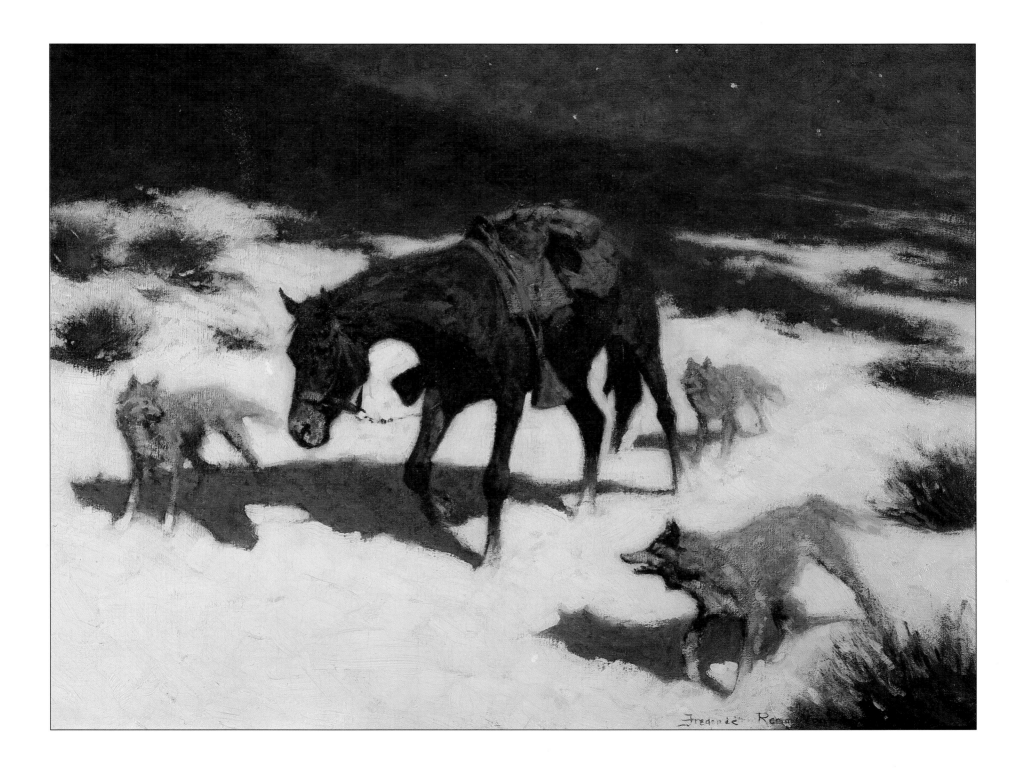

day, Remington watched his old friend lead a mad rush for the enemy's positions. By late afternoon it was over and Roosevelt stood on the crest of a hill overlooking Santiago. A Spanish counter-attack at 3 a.m. came to nothing and the Americans were able to begin the siege of the city.

That charge up San Juan Hill consolidated the reputation of Theodore Roosevelt. A celebrity in New York State, he was now a national hero. His heroic exploits and the romantic appeal of his frontier Rough Riders caught the public imagination. Later that year he would be elected Governor of New York, putting him firmly on the road to the Presidency which he would occupy just three years later.

The night after the battle Remington would have conversed with the soldiers as they returned to their trenches for the night. He may have heard about the bizarre behaviour of Colonel 'Fighting Joe' Wheeler. As a young man Wheeler had fought in the Confederate cavalry at Shiloh and Chickamauga. As the fighting became intense on San Juan Hill, he turned to his men and ordered the charge. 'Those damned Yankees won't stop us now,' he yelled, getting his enemies confused in the excitement.

Next morning Remington made arrangements to move up into the hills to join Roosevelt in the siege lines. But he was feeling even more ill than on the day of the battle and by evening was diagnosed as suffering from malaria. The doctor ordered his immediate return to the United States and Remington reluctantly left the scene of the fighting to return home.

Although his time in Cuba was exhilarating, it does not seem to have affected either Remington's style or career to any great extent. On his return he turned again to making bronzes. *The Wicked Pony* was completed in 1898, though for some reason only 10 castings were made and sold. Rather more successful was *The Scalp*, which ran to several dozen castings. The piece, another single horseman, shows a plains tribesman lifting high a scalp as a symbol of victory in a fight.

It was while *The Scalp* was in the progress of being cast that the Henry-Bonnard bronze casting works burned down. The original cast of the sculpture was seriously damaged in the blaze and the workshops so damaged that the company went out of business. But what was a disaster for Henry-Bonnard and

The Scalp *(1898)*
Bronze. Height 25⁷/₈ inches (65.7 cm).
Amon Carter Museum, Fort Worth, Texas.

appeared to be just as unfortunate for Remington actually proved to be a blessing in disguise.

Remington's attention was drawn to some bronzes being produced by the Roman Bronze Works, a factory owned by an Italian immigrant named Bertelli. The process they used was entirely different from that used at the Henry-Bonnard works. Sand casting of bronze produced exact replicas of original models, but was rather lacking in surface finish and detail. Bertelli's lost wax method allowed more flexibility of finish, and also allowed each casting to be altered or details changed by the artist. Remington approved. Thereafter his works often appeared in a number of different forms as he experimented with small details of dress and posture. His first sculpture, *The Bronco Buster*, was recast in 1909 by Bertelli and Remington worked in several changes, including fur chaps on some castings.

In 1899, Remington's steadily growing income allowed him to move home yet again. This time he bought an entire island in the St. Lawrence River where he could escape from unwelcome visitors and interruptions, yet be still close to his old family home in Ogdensburg. He built a cottage and a studio in which to work, specially designed to match his requirements. A huge window, occupying most of one wall faced north to provide plenty of even, indirect light. Outside the window stretched a simple verandah where Remington could sit and gaze at the trees and the river when the mood took him. The house was only intended as a summer retreat, as even then the nature of his profession caused him to spend the majority of his time in New York City.

The summer of 1899 saw him undertake an extensive journey through the northern plains and into the Rockies. He returned in 1900, but something was missing, and Remington noticed it. In 1893, the historian Frederick Turner had declared: 'The Frontier is closed.' No longer was there a line of settlement beyond which there were less than 2 people per square mile. The effect in the West was not immediately apparent, but as the land began to fill up with farmers, preachers and shopkeepers, its character changed. In place of wild frontier law, enforced by sheriffs handy with a gun, there were now law courts and juries. Gone were the great cattle drives, now replaced by fenced-in paddocks and specially bred beefs. The tribes which had once possessed cultures and languages as distinct as any nation's, were now being moulded into the life of white America. The West, the object of Remington's passion for almost 20 years, was practically extinct and he was dismayed to find his travelling days out West were now without purpose. From then on he began to paint the past rather than the present, and his style and view of the world changed accordingly.

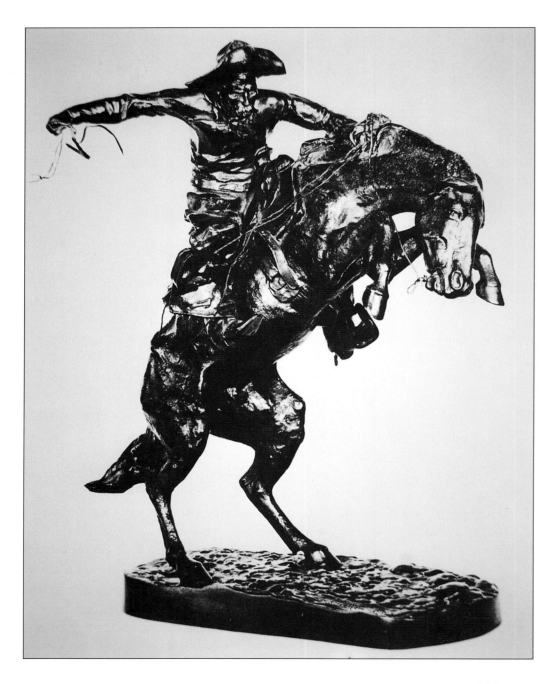

The Bronco Buster (1895)
Bronze. Height 23$^{1}/_{4}$ inches (59.2 cm).
Amon Carter Museum, Fort Worth, Texas/
Peter Newark Western Americana

Chapter Seven
A View from the East

As the romantic image of the old West began to fade, so Remington's style underwent a sea-change. He gradually abandoned his quest for absolute realism and began to search for ways to capture on canvas the essence of an age which would never return.

At first, Remington tried to compensate for the paucity of colourful incident emanating from West by returning to past events. In 1897 he produced the epic oil, *A Sergeant of the Orphan Troop*, but which is now known as *Through the Smoke Sprang the Daring Young Soldier*. The canvas shows an incident from the Cheyenne rising of November 1876 when a large group of tribesmen was cornered by a detachment of cavalry. One troop of cavalry found itself pinned down by heavy rifle fire, but was saved when Sergeant Carter Johnson leapt from cover and raced forward to take the first enemy position. The moment of Johnson's heroic feat is vividly captured by Remington with the chill snows lying thick on the ground and the soldiers in their winter gear.

Remington also worked from fictional tales of the vanishing West. In 1902 he produced *The Hold-Up*, an oil illustrating a story by Richard Davis. In the story, an army officer with a sense of humour holds up a stage armed only with scissors in place of a Colt in an attempt to relieve the loneliness of his isolated post. He later goes on to woo the daughter of the post's trader; but it was the hold-up which Remington chose to depict.

But Remington was becoming increasingly disenchanted with searching for inspiration in the realms of past events and fictional accounts. He endeavoured more and more to capture the very spirit of the West, rather than record old anecdotes of its past. It was this spirit of rugged individuality and self-sufficiency which Remington had so admired when he met the freight driver who opened his eyes to the ways of the frontier. Now that so much had disappeared, Remington felt the urge to record that feeling for posterity. He had witnessed a vivid and dramatic stage in American history and felt that future generations would be more than interested to know how it had felt to be alive at that time, possibly more interested in that than in historical events, exciting as they undoubtedly were.

One of the first canvases to clearly demonstrate this new trend was *The Cowboy* of 1902 (page 70). In this, one of his most famous works, Remington portrays the classic cowboy of everyone's imagination, mounted on a cow pony as it gallops and slithers down a steep, rocky slope. Beyond is a small herd of ponies which the cowboy is in the process of rounding up. There is no attempt to tie him to one particular place or time. His equipment is of no particular type, neither Texas nor Wyoming, for Remington is not interested in depicting one particular cowboy, he is attempting to immortalize *the* cowboy.

Clearly Remington was well on his way to a new style of painting in which precise outlines and small details become more subtle and less clearly defined. At long last Henry Harper's wish was coming true and Remington was borrowing and learning from other schools of art. This was not, however, the result of Harper's influence or of the visit to Europe: it had grown out of Remington's own desire for change.

There are several factors which may have pointed Remington in this new direction. When in Paris, Remington would have come across the innovative Impressionists. What he made of their work is unknown, but his own later preoccupation with light and shade may indicate that he had more than a passing interest in their technique. Around the turn of the century a group of American artists, including his friend Robert Reid, decided to introduce Impressionism to the New World. Remington never formally joined their ranks, but he visited their exhibitions and enthused about their works to critics. Their influence on his own paintings is unarguable. Another major influence was Charles Peters, whose nocturnal scenes were displayed alongside Remington's works in an exhibition in 1901. It was around this time that Remington began to produce distinctly impressionistic works, often landscapes perceived at night.

But Remington also found himself playing the unaccustomed role of elder statesmen to a younger generation of new artists taking up their brushes for the first time. The former cowboy, Charles Russell, came to New York for the first time in 1903. Russell had been gradually gaining ground in the public eye. From small sketches for his cowboy friends, Russell had progressed to oil paintings. Under the efficient management of his wife, Russell produced carefully delineated paintings of jocular or thrilling moments of Western life.

With his background of ranch life, and his experience of living with the Blood tribe for some months in 1888, Russell was able to impart an earthy realism to his paintings. The vast majority of his works were based on real incidents; Russell knew many cowboys and scouts and drew on their anecdotes for his subjects which were beginning to monopolize the market. His trip to New York in 1903 was most productive: Russell received orders from several magazines and made many contacts which would later advance his career as a painter. He was, as yet, neither so famous nor so popular that he was a direct threat to Remington. But Russell did meet a man in New York who was both these things: Charles Schreyvogel.

Schreyvogel had entered the public eye in 1900 as an entirely unexpected hit of the 1900 National Academy Exhibition. At the time, the Academy judging committee had no idea who he was and it was mooted that 'Schreyvogel' might be a pseudonym for an already-famous artist. But Schreyvogel did exist. He was relatively unknown because he had spent some years working in Germany and, on his return to the United States, had concentrated on producing more profitable lithographs rather than oils.

The painting which made such an impact at the 1900 show was entitled *My Bunkie,* and was a subject close to Remington's heart. In the picture, a cavalry trooper is lifting his wounded bunkmate from the ground so that he can escape on his horse, while two companions provide covering fire. The scene is set in a dusty landscape reminiscent of the Arizona deserts of the Apache Wars. Remington had himself already tackled the subject of a cavalryman under fire, coming to the aid of his bunkmate in the bronze *The Wounded Bunkie* (page 67), and in several magazine illustrations as well. Remington's feelings were rather ruffled by

newspaper reports as more than one compared the work to Remington's.

The *My Bunkie* affair led to animosity towards Schreyvogel, though the newly popular artist refrained from responding to the criticism coming from Remington and by the time of Russell's visit the artistic rivalry between the two men was at its peak. The cause of the very public criticism coming from Remington at this time was a painting of Schreyvogel's entitled *Custer's Demand*. Once again Schreyvogel was depicting Western soldiers in the field, a subject Remington had made his own. As the newcomer had neither been on campaign nor spent much time in the West, Remington felt able to criticize his work as lacking in authenticity. In an article in the *New York Herald*, Remington denounced the picture as 'half baked stuff' and the note of scorn in the article was unmistakable.

But Remington had misjudged his man. Schreyvogel had worked closely with veterans of the Sioux Wars, even Custer's widow had been consulted. They leapt to the defence of the artist they considered to have depicted their hero so well. Remington's criticisms were answered one by one. Details of uniform and outfit rejected by Remington were vouched for by men who had been on the campaign. For the first time it appeared to the public that Remington did not know what he was talking about when it came to the West. He was both humiliated and angry.

The results of this public dispute were far reaching for Remington. After exhibiting in every National Academy exhibition for some years, Remington refused to enter his work ever again. He also informed his customers that he was no longer interested in portraying specific historical events but would prefer to work towards the greater truth which lay behind the Western character and culture.

His first chance to do just that came in the spring of 1903. *Collier's Magazine* was so impressed with the results of Remington's recent venture into the world of Impressionism that they decided to give him what was, for an artist, a marvellous opportunity. He was commissioned to produce a colour painting a month for a fee of $1,000 each. The pictures were to be reproduced in *Collier's* in full colour, using the latest printing techniques, the subject matter to be entirely of Remington's own choosing.

Remington set to work with a will. Some of the pictures were one-off subjects but others were arranged in series, the most ambitious being *The Louisiana Purchase*, which ran to 12 paintings. The pictures showed various stages of the European settlement of the area beyond the Mississippi from the first fur trappers to the farmers. *The Great Explorers* was almost as big a project, running to ten canvases in all.

But the commission was not to be Remington's happiest. Freed from the constraints of painting subjects or incidents stipulated by his employer, Remington found himself slightly at a loss. Combined with a growing disregard for strict accuracy in matters of equipment and dress the unfocused subject matter gave rise to criticism. His admirers lamented the loss of narrative and authenticity in his paintings, while Remington was not far enough down the road to Impressionism to have made his mark in that genre.

It is beyond doubt that Remington himself was ultimately unhappy with these pictures. In 1908 he burned *The Great Explorers* and several other of the *Collier's* pictures. Yet he could not let the matter rest. The ashes were barely cold when he began work on new versions of the destroyed paintings. The first version of *The Unknown Explorers*, a view of a bearded mountain man and his wife, was painted for *Collier's* and burned in 1908. That same year he produced a second version. In the second painting the characters are in almost identical poses and the composition is similar, though the wife has now been replaced with a local Indian guide. In other ways the paintings are very different. The clearly drawn rocky landscape of the first has gone and been replaced with an impressionistic mass of sand and rock.

This was not the only time that Remington reworked earlier paintings. He produced no less than three versions of a 1904 painting intended for *Collier's*. *The Scouting Party* is a small oil just over a foot in height. It shows a number of Indian scouts, one on foot, searching the ground for signs of the men they are following. Behind rides an Army officer scanning the landscape and behind him a troop of cavalry follows. A much larger oil, over 50 inches (130 cm) wide and named *Pony Tracks in the Buffalo Trails*, was completed for *Collier's* and it is generally thought that the smaller picture was a rough completed to confirm details of composition and colour. The purpose of the third version, an oil of 11 x 19 inches (28 x 48.2 cm) is unclear. It differs from the others in several details, but not enough to mark it as a totally different concept.

If Remington had temporarily lost his way with oils, the same was not true of his bronzes. In fact this period saw some of his greatest and most popular sculptures with the appearance of *Coming Through the Rye* in 1902 (page 74). This exuberant work was his largest to date and shows four cowboys galloping into town intent on a wild night of fun. The work was recreated in giant form as the gateway to the Lewis and Clark Exhibition of 1905 and has appeared in print many times. The next year saw *The Mountain Man* (page 81), a superb study of man and horse working in unison in a harsh terrain.

The bronzes were now coming fast and thick. 1904 saw *The Sergeant* (page 93), a bronze bust of an archetypal frontier cavalryman and the following year Remington produced two key works. *The Rattlesnake* (page 95) shows a cowboy perched on a horse rearing up unexpectedly as it encounters a deadly rattlesnake. It is generally accepted as his finest single figure, aspects of grace and terror being strikingly portrayed. But the most outstanding work that year, from a purely technical point of view, was *The Old Dragoons of 1850* (1905). This work includes no less than four men and five horses and shows a pair of cavalrymen in hand-to-hand combat with Plains tribesmen while riding at full tilt. It measures $25^{3/8}$ inches (64.5 cm). So large and complex was this work that a number of castings went badly wrong and only nine were ever completed.

Other smaller works followed, but Remington was still interested in large, multi-figure castings. In 1909 he finally mastered the technique with *The Stampede*. In this work a mounted cowboy is plunging ahead at full gallop trying

to control three terrified steers as they rush headlong over a grassy plain. The work is nearly 3 inches smaller than *The Old Dragoons of 1850*, but its cleaner lines and less fussy detail made it easier to cast. It is thought that 15 of these works were completed, but the total is in dispute.

Meanwhile Remington continued to work in oils. If his impressionistic historical scenes were controversial, his nocturnes found a ready audience. It is possible that because these works were a new departure for Remington they were not compared with earlier works but judged on their own merits. The first to receive popular acclaim, and one which is still viewed as a great Remington, is *The Old Stage Coach of the Plains* (page 79), completed in 1901. The brilliance of a full moon and starlit night is well captured, as is the watchfulness of the guard perched atop the coach with his rifle. The picture is in portrait format, unusual for Remington, and the horse team moves down a slope towards the viewer. The picture first appeared as a coloured magazine illustration in *The Century* to accompany an article by Emerson Hough on historic forms of transportation.

By the time Remington produced another night scene, *A Taint in the Wind*, perhaps his masterpiece, another five years had elapsed and he was more firmly entrenched in the Impressionist school of thought. The whole scene is pervaded with a green tint, adding an air of mystery to the spectral moonlight. Again, the subject is a stage coach on the western plains, with a rifle guard on the roof. But here the watch is interrupted by a sudden alert as the team of six horses shies

dramatically away from some person or object out of view to their left. The viewer is left to wonder just what has spooked the horses and caused the driver and guard to peer fearfully into the middle distance. In style, the picture is almost pure Impressionist with bold strokes of the brush and blurred outlines. Light and colour are the most important elements of this painting rather than the stark lines and silhouettes of the earlier nocturne.

Soon afterwards Remington decided to make changes to his life. The town of New Rochelle was rapidly expanding to become a crowded and noisy place. No longer was it the tranquil backwater to which he and his wife had retreated when Remington needed peace and quiet for his work. In 1906 he had been visiting a friend Alden Weir in Connecticut. He now decided that the town of Ridgefield was the place to live. He bought a plot of 13 acres, remote enough to discourage casual visitors, and drew up plans for building.

Remington was determined to provide himself with the perfect ambience for serious painting, the focus of attention being, of course, the studio and it was designed to be his largest yet. Like the one at his island summer home of Ingleneuk, it had vast windows to let in as much light as possible; but it was much more spacious with shelves on which to display his large collection of Western artifacts where they would be easily accessible rather than stored away in attics and boxes. It was here that he produced his great bronze *The Stampede*.

By 1909 the transition to Impressionism was complete. Remington produced no less than 23 large canvases in this style for a one-man-show at the galleries of

the dealer Roland Knoedler in New York. In *The Buffalo Runners, Big Horn Basin*, Remington depicts a band of Plains tribesmen cresting a hill as they gallop at full tilt in pursuit of a herd of buffalo. The figures and horses are masterpieces of light, shade and subtle brushwork. The pace and excitement is beautifully captured and Remington considered it to be one of his best works.

The Knoedler show opened on 29 November 1909 to great critical acclaim. The most severe art critics, who had earlier castigated Remington for producing mere 'illustrations in oils', were won over by the sheer mastery of technique displayed in these works. Remington had arrived as a highly respected painter, judged a master by his most illustrious contemporaries as well as by the public at large.

A few days after reading praise of his exhibition in the reviews, Remington collapsed with severe stomach pains. His doctor recognized the signs of a ruptured appendix and operated immediately but it was already too late. Infection set in and Remington died on 26 December 1909. He was just 48 years old.

Compared to other painters of distinction Remington enjoyed an all too brief career as an artist. Some purists believe he only really began to produce masterpieces after the dispute with Schreyvogel set him on the road to Impressionism. Others believe his earlier works have just as much artistic merit, being different in style rather than inferior to his later work. But whatever one's view of his work, there can be no doubt that Remington was a master of his genre and a painter of genius. His early illustrations revealed the true face of the West to people who had never experienced it and his later paintings immortalized the characters and events he knew and loved as a young man. If any one person could claim to have brought the romance of the Wild West to life, and preserved it forever, that man is Frederic Remington.

'He Gave Us the Wild West for Keeps' (1938)
by Harold von Schmidt
Peter Newark Western Americana courtesy of the John Hancock Mutual Life Insurance Company, Boston, Mass.

INDEX

Page numbers in *italics* refer to illustrations